MACCLESFIELD

THROUGH TIME

Paul Hurley

AMBERLEY PUBLISHING

Acknowledgements

This book would not have been possible had it not been for my good friend Ron Frost who allowed my unfettered access to his large collection of photographs and postcards and assisted me greatly in identifying obscure locations. If you would like to view his Macclesfield archive, you can find it at: www.oldmacclesfield.co.uk

I would also like to thank Philip Broadhurst for the loan of his photograph, my brother Bill who lives in the town and provided welcome cups of tea, Ruth Lear of the excellent West Park Museum and Neil Boothby of Macclesfield Town FC for providing the photograph of the team. Once again, I would like to thank my lovely wife Rose for her patience during the not inconsiderable time it took to complete the book and for her time spent with me taking the modern photographs.

Bibliography

Fiction
Liverpool Soldier

Non-Fiction
Middlewich (with Brian Curzon)
Northwich Through Time
Winsford Through Time
Villages of Mid Cheshire Through Time
Frodsham and Helsby Through Time
Nantwich Through Time
Chester Through Time (with Len Morgan)
Middlewich & Holmes Chapel Through Time
Sandbach, Wheelock & District Through Time
Knutsford Through Time

First published 2012

Amberley Publishing
The Hill, Stroud
Gloucestershire, GL5 4EP

www.amberley-books.com

ISBN 978 1 4456 0759 7

The Author

Paul Hurley is a freelance writer, author and is a member of the Society of Authors. He has a novel, newspaper and magazine credits and lives in Winsford, Cheshire with his wife Rose. He has two sons and two daughters.

Contact: www.paul-hurley.co.uk

All modern photographs, except the football team, were taken by the author.

British Library Cataloguing in Publication Data. A catalogue record for this book is available from the British Library.

Typeset in 9.5pt on 12pt Celeste.
Typesetting by Amberley Publishing.
Printed in the UK.

Introduction

The county of Cheshire once incorporated at its extremities such towns as Stockport, Hazel Grove and Dukinfield, all north Cheshire conurbations. In 1974 that changed, albeit that most still give themselves a Cheshire postal address and not a Greater Manchester one. The town of Macclesfield remained in Cheshire and apart from Disley is the farthest from the County town of Chester. It spreads out into the beautiful Peak District and has villages with such wildly romantic sounding names including Wildboarclough, Pott Shrigley and Wincle. There is also the village of Langley on the edge of Macclesfield Forest, which once housed Langley Mill, founded in 1826 and at the time, was the biggest silk printing, dyeing and finishing works in the world. The Mill is still there but serves a different purpose.

The town's name is believed to originate with the word Maccels in old English, meaning open space and another suggestion is that it comes from the name of a landlord called Macca, Macca's field. Whatever the true version, the *Domesday Book* lists Macclesfield as Maclesfeld. It soon became Silk Town where in 1872, seventy-one silk mills operated. There are a number of silk industry museums in the town where all aspects of silk history and workings can be found; as the Silk Road once stretched from China to Europe and the recognised end of that route is the town of Macclesfield. Silk Town later became Treacle Town to the locals when it is believed a barrel of treacle was spilt on Hibel Road and the poor of the area rushed out to help themselves. That is one reason, another is that a performing bear loved the stuff and when he broke free treacle was laid as a trap to re-capture him.

In 1244, John Le Scot Earl of Chester, who resided here, died without issue and the lands were annexed to the Crown forever. Prior to this, the town was walled with three principal gates named Jordan gate, Chester gate and Wall or Well gate; names that can still be found in the town although the walls have now long gone. On the invasion of England by the Scots in 1573, the Macclesfield inhabitants were active in repelling the invaders and as a result, Town Mayor Charles Savage and many townsfolk were slain on Flodden Field. The town suffered greatly from The Plague in 1602 to 1603 and then soon after came the English Civil War in which the town was defended for the King by Sir Thomas Aston. The town then experienced 'much injury' at the hands of Parliamentary troops under Sir William Brereton, at this time the spire of St Michael's church was severely damaged by cannon fire.

But what of the town today? I would have liked to put the town hall on the front cover but unfortunately it is undergoing a long period of renovation and is covered in scaffolding and

white plastic. This handsome building, built of stone in a classical Grecian style in 1823 to 1825, stands majestically in the market place. It was enlarged and new fronted in 1869 to 1870 and housed the magistrates court, the Borough Police Headquarters with the chief constables office, a large assembly room and on the ground floor a butter and corn market. Accordingly, I have chosen the pleasantly named Waters Green area of the town with St Michael's church on the top of the hill looking down towards the station and out over the hills of the Cheshire Peak District. The church was founded by Eleanor, wife of Edward I in 1278, and then in 1740, it was enlarged and rebuilt.

Macclesfield and its surrounding towns and villages such as Wilmslow, Prestbury, Alderley Edge and Mottram St Andrew to name but a few, are some of the most desirable postcodes in Cheshire and some of these towns and villages will feature in my next book, *Cheshire Through Time*.

All of these brief details are a taste of what is to come within the pages of this book of then and now photographs, with their well researched captions between the old and the new. It is a book that you can browse and browse again, seeing subtle differences on each page. Enjoy it as I have enjoyed compiling it.

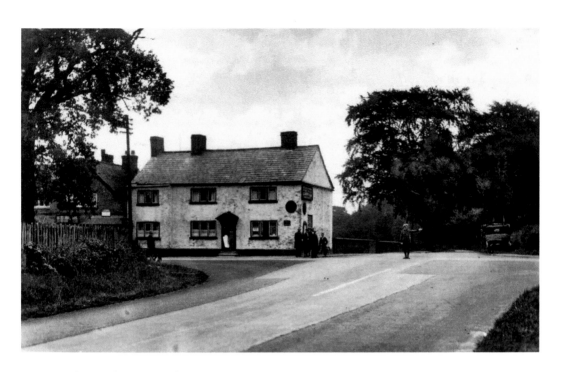

Monks Heath Crossroads, 1920s

We start our tour of Macclesfield from the Knutsford direction and the first stop is Monks Heath. This crossroads is situated on the roads to Alderley Edge, Macclesfield, Congleton and of course, Knutsford. In this first set of photographs we walk into Congleton Road and look across at the cottages that have been there for many years. The RAC man is directing traffic although as there is none; it is more than likely a posed shot for the camera.

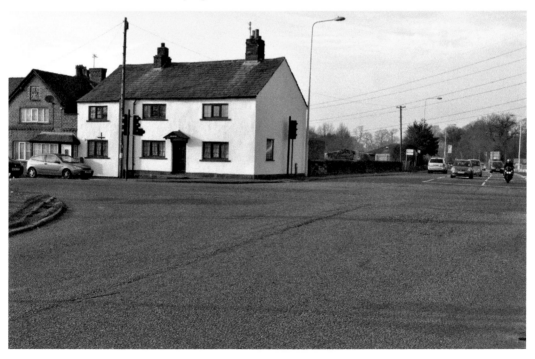

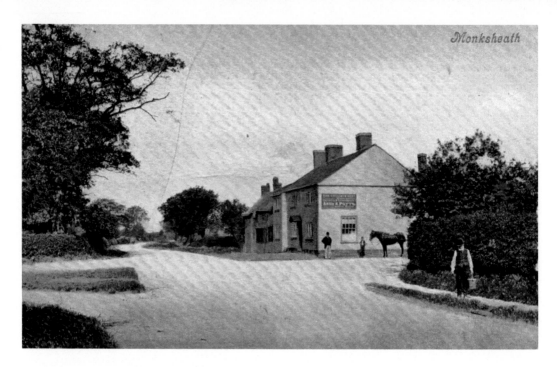

Monks Heath Crossroads, late 1800s

Now we walk towards Macclesfield and look back at a much earlier photograph of the scene. The sign on the wall says Aked & Potts. In 1880 J. E. Aked was a soft drink manufacturer in Catherine Street and later Aked Pott & Goodwin Ltd. of King Edward Street, Macclesfield manufactured mineral water, cordial and bottled Ale and Porter. This was a refreshment stop called The Cyclists Rest, for travellers on this intersection. In the modern photograph we see that a cottage was later built next door in 1905 and has the name Nurses Cottage.

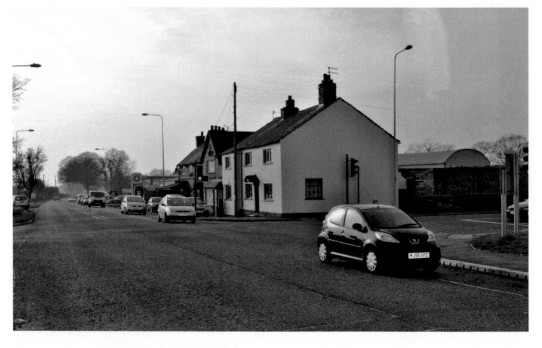

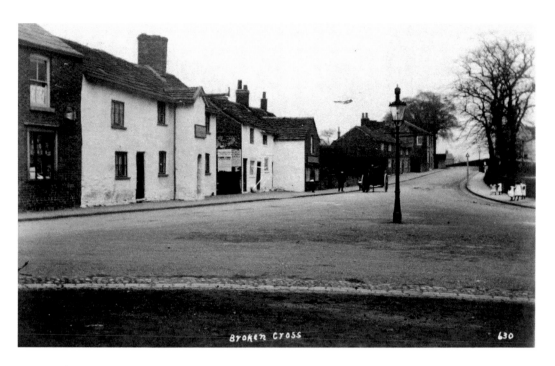

Broken Cross, *c.* 1900

Continuing into Macclesfield now we reach Broken Cross and we look towards the town with the Bulls Head pub on the left. As can be seen, there has been some alterations to the front of the pub and the buildings around it over the years. There is a remodelled front and the roof has been modernised.

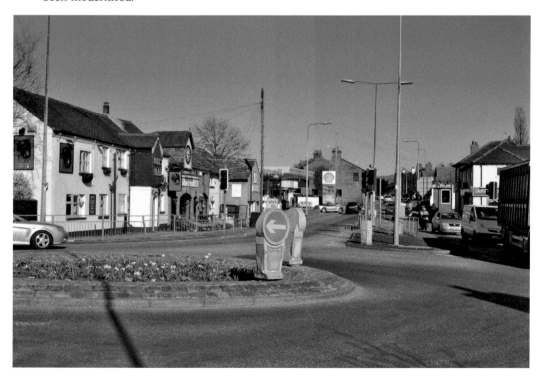

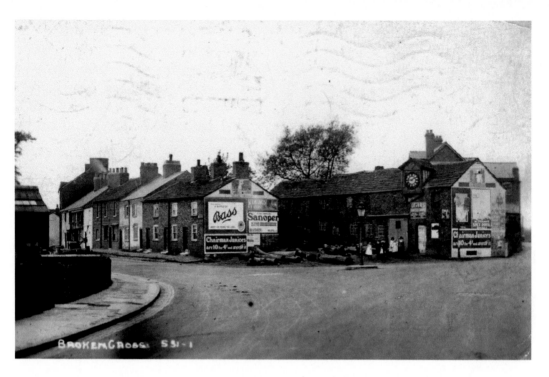

Broken Cross, 1920–1930

This old photograph, filled with period advertisements is undated but I would estimate that it is in the 1920s. The clock on the roof is similar to the one that is now across the road on one of the newer buildings. The large barn with the clock has gone to make way for the roundabout but the large house at the rear of them is still there, as are the cottages.

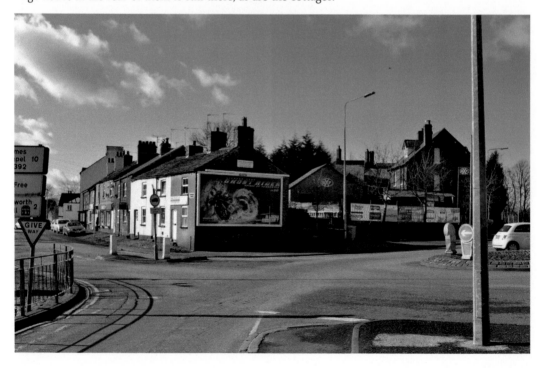

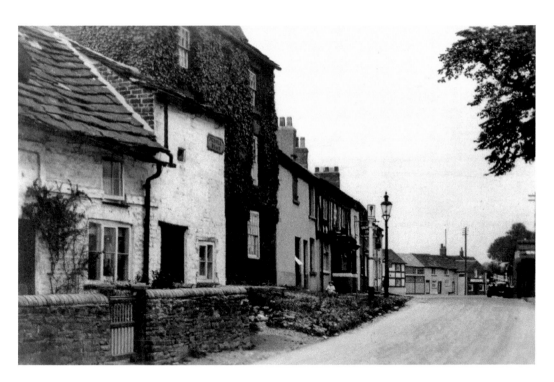

Pexhill Road, 1930–1940

We walk down Pexhill Road now and look back towards the roundabout. Little has changed here over the intervening years, although the small house after the large one has gone and the large one has lost its verdant coat. The Bulls Head in the distance is yet to be modernised.

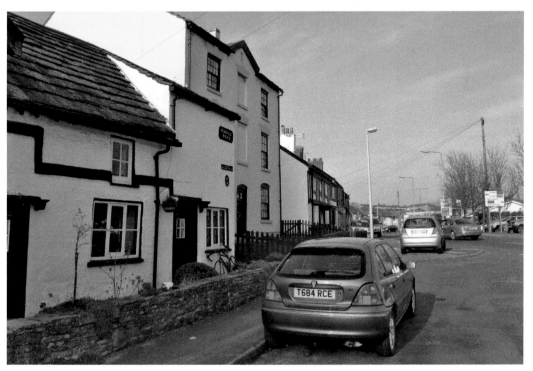

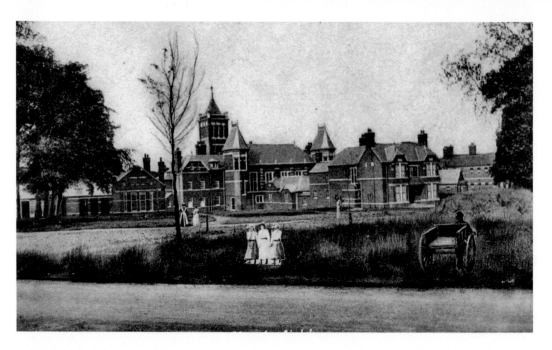

Parkside Hospital, late 1800s

I have included this poor and well doctored old photograph as most of it has now gone and it was an important part of Macclesfield. Built in 1868–1871, it then had the politically incorrect name of The County Lunatic Asylum. Later additions gave it its own infirmary, a facility for difficult cases, a new wing for epileptic patients, a church and an isolation hospital. There was also a 60 acre farm, workshops and a laundry. All of these additions were made before 1900, making it one of the largest of its kind in Britain. It could accommodate around 800 patients. It closed in 1997 and most of it was replaced with a housing development.

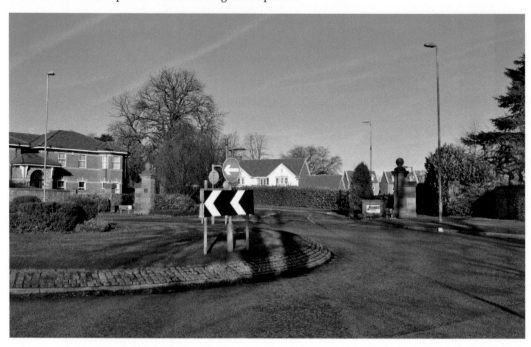

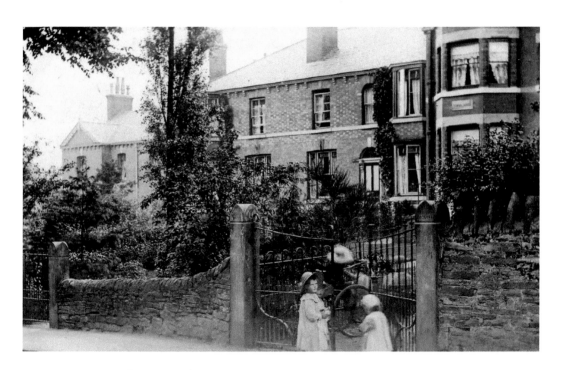

West Mount Chester Road, c. 1900

This is the road from Broken Cross to Macclesfield town centre and we can see how routes of this nature have become busier over the years. On the right the walls have gone at the location although the gate posts that the children are in front of are still there, they have the words 'West Mount' engraved upon them. The photographer of old has positioned himself in the centre of the road, I could not!

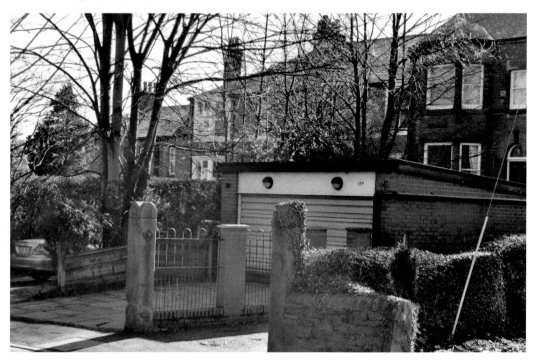

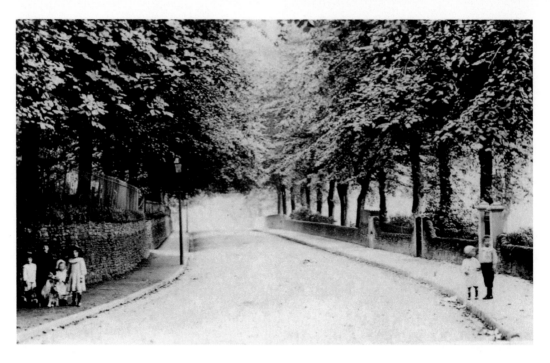

Chester Road, early 1900s

This photograph is a good indication of how things change over the years on our roads. Chester Road today is a busy arterial road from Broken Cross to Macclesfield and here we can compare it today with 100 or so years ago. At least the gateposts that the boy is standing in front of are still there.

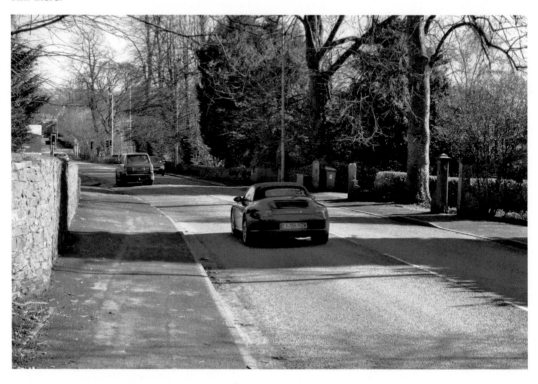

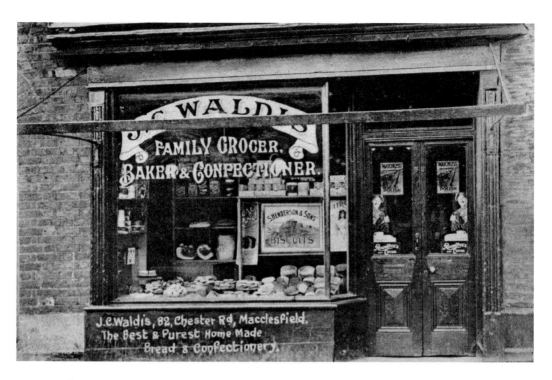

82 Chester Road

Continuing along Chester Road we reach the roundabout and cross it into a continuation of that road. The photograph is undated but I would estimate it to be the mid-twentieth century when the shop was a baker and confectioner. It is now a wine shop.

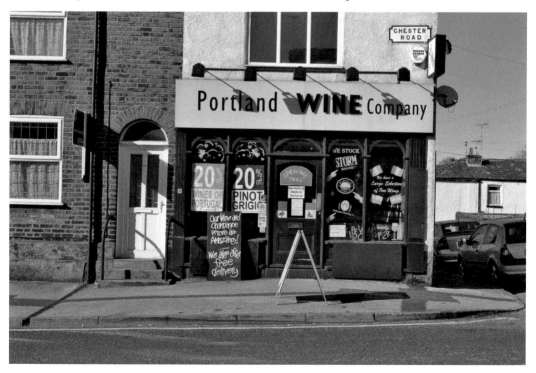

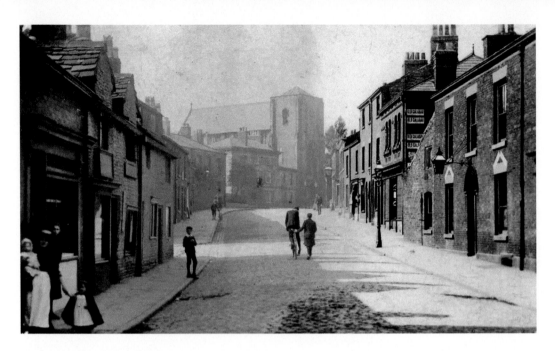

Chester Road, early 1900s

Here we have a little changed area of the town with the Catholic church of St Alban in the distance. The church was built between 1838 and 1841 at a cost of £10,000 and was designed by Mr Welby Pugin. The roof appears unfinished but that is how it was built, being described at the time of building as 'an incomplete tower'. Note that the small building with the sloping roof on the right has been rebuilt, but apart from that, little has changed.

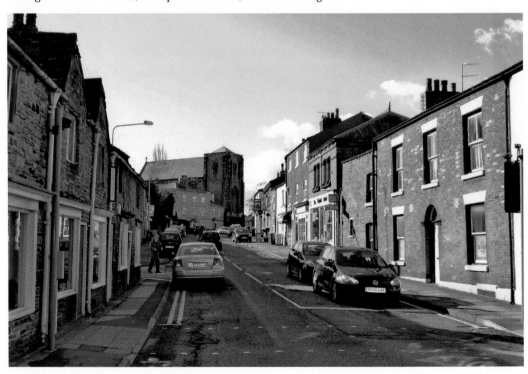

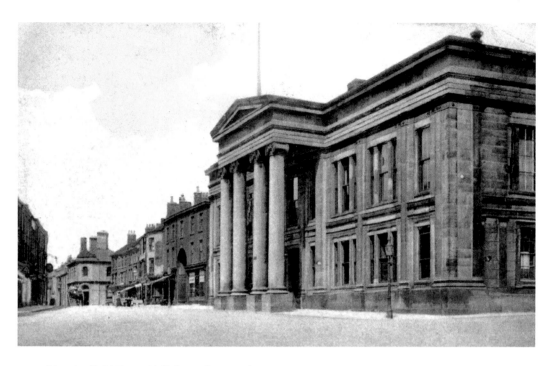

Macclesfield Town Hall, late 1800s early 1900s
This photograph shows just how hard it is to compete with building work. The town hall is in the process of a refurbishment on the 19 February 2012 and an earlier photograph shows a bit more of it as the scaffolding work had only just started. Originally it had a large assembly room and beneath this a butter and corn market. It also housed the Macclesfield Borough Police Headquarters and in 1896 William Sheasby was the chief constable; strangely, in 1934 Henry Sheasby was shown as the chief constable, his home address was 151 Chester Road.

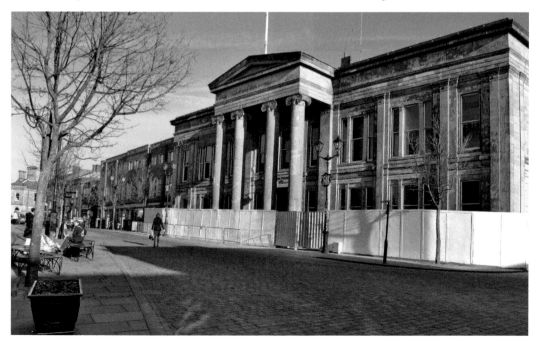

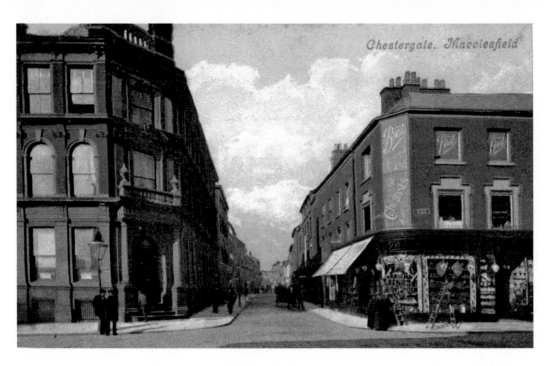

Market Place into Chestergate, late 1800s early 1900s

Here we look from the market place into Chestergate and we see another 1800s photograph that has been tinted for use as a postcard. There has been quite a lot of change on this corner although the Cooperative building on the right has been built to look like the original.

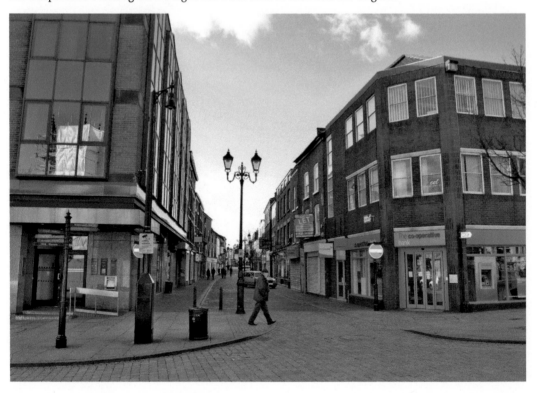

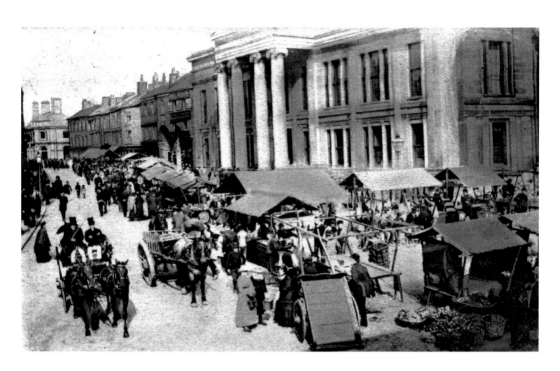

Macclesfield Market, late 1800s

I managed to get a photograph of the town hall when it just had a fence around it. The next time I visited it had disappeared under a covering of scaffold and this was to be completely encased in plastic sheeting whilst the work was carried out. The old photograph is not that good but shows the market at its busiest sometime towards the end of the 1800s.

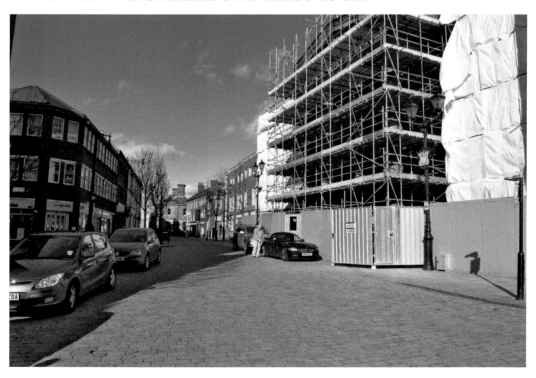

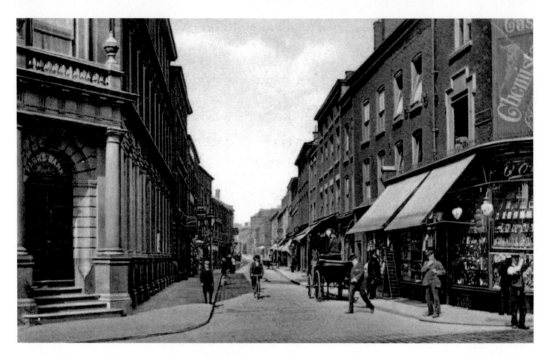

Chestergate from Market Place, *c.* 1900

A final snapshot in time of the view into Chestergate at the turn of the last century or possibly even earlier. It is almost like a Lowry painting with the individuals going about their business and only the boy taking any notice of the cameraman, while the man on the right ponders whether to visit the market or not!

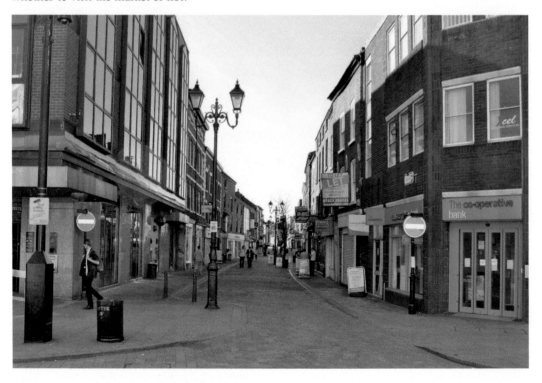

Chestergate, *c.* 1900

A few views now of this important shopping area as we look through towards the market place and the town hall. On the left, hidden by the tree in the modern photograph, is the sign of the Bate Hall pub. This ancient hostelry is said to have existed from the sixteenth century but evidence of an earlier date is present. It was originally the family home of the Stopford family, Earls of Courtown, who were landowners in the area. James George Henry Stopford sat in the House of Lords as Lord Saltersford (a hamlet five and a half miles from Macclesfield). The family seat was in County Wexford. 'Beate-Hall' was described in 1810 as 'a decayed mansion, occupied as a public house'. By 1870 it was the Batehall and Peter Simpson was the licensee.

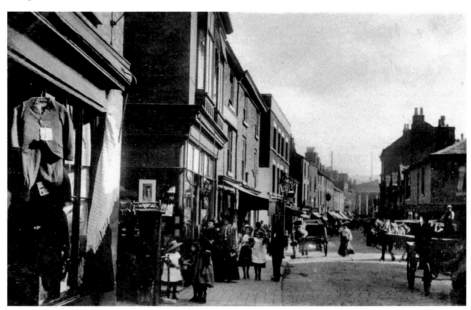

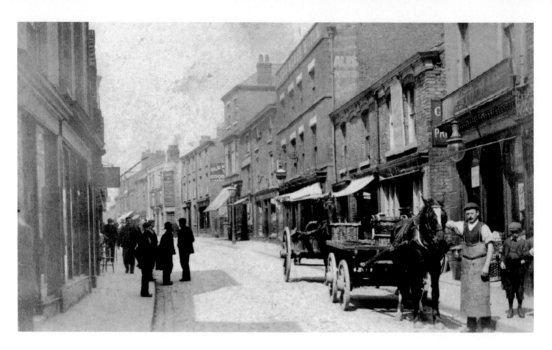

Chestergate, *c.* 1900

We turn around now and look away from the market place towards Churchill Way. Apart from a few buildings removed over the years, not much has changed. The Old Kings Head can just be seen behind the ubiquitous white van; in 1879 Charles Earlam was a butcher and a farmer as well as being licensee. The Flying Horse Hotel nearer the camera had Ralph Worthington in charge. Most pause to observe the cameraman with his tripod and heavy camera.

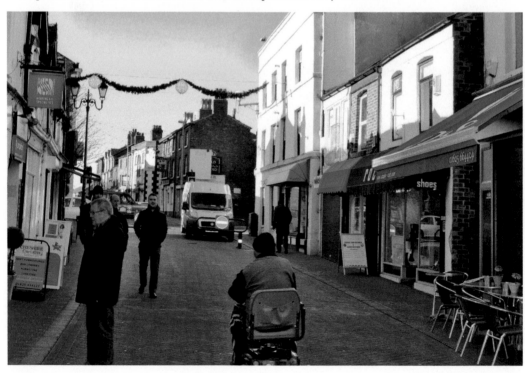

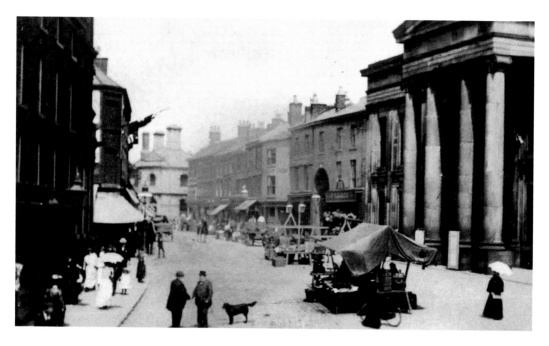

Market Place, late 1800s early 1900s

A similarly dated photograph to the last at this location; but of better quality, with a look at the scaffolding that has now temporarily obliterated the superb building. In the old one we see two rotund gentlemen shaking hands on what? Maybe a good business deal.

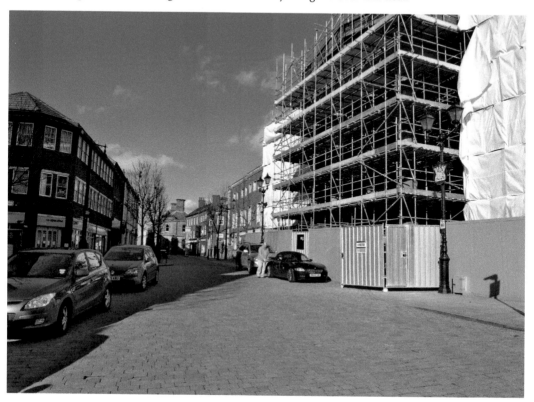

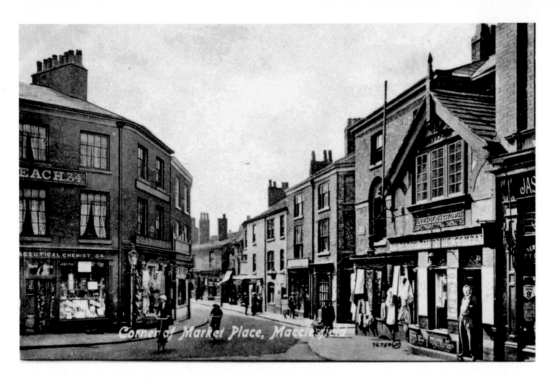

Market Place into Mill Street, c. 1910

This is a view from the market place into Mill Street, with the large building housing Isaac Leach Pharmaceutical Chemists at 34 Market Place on the left in the old photograph. This will date from the turn of the last century. Ye Olde Shop on the right was the same as it is now other than it was then The London Tailoring Company and it is now Donald Massey Jewellers.

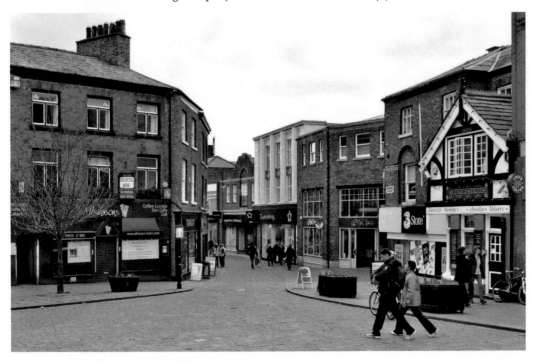

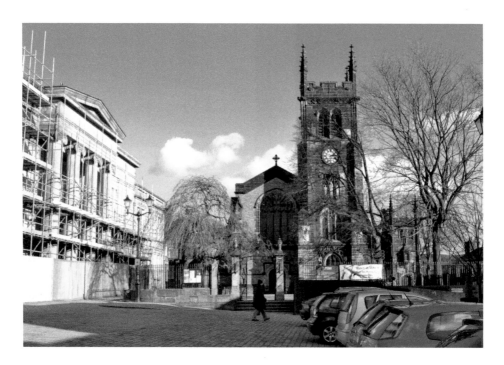

St Michaels by Town Hall, Undated

Sitting alongside the town hall on the brow of the hill, the parish was formed in October 1835 although the church itself was founded in 1278 when it was consecrated by the Bishop of St Asaph. Over the years, many distinguished families were buried within its walls. Some like Baron Stanley, have effigies above the tombs depicting them in suits of armour. An interesting little aside is that some are described as 'wearing a collar of SS'. This is a decoration restricted to the Lord Chief Justices of the Queen's Bench, the Lord Chief Baron of the Exchequer, the Lord Mayor of London, the Kings-of-Arms, the Heralds, the Sergeant-at-Arms, and the Sergeant Trumpeter. More on the church later.

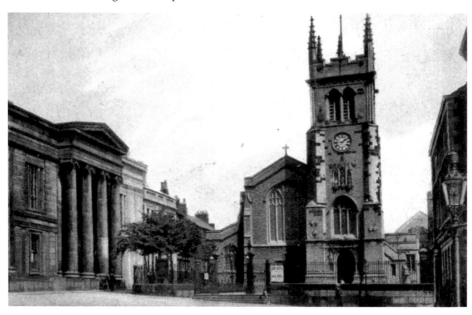

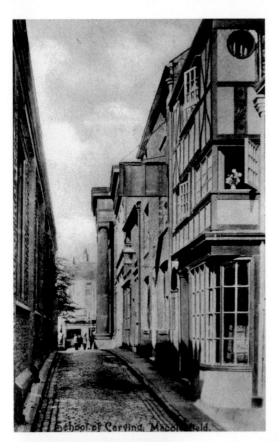

Side of Town Hall, Undated
This slightly altered area has the caption 'School of Carving Macclesfield'; it is known that the work of the students here has been incorporated into local buildings such as the old and listed Christ church in Great King Street.

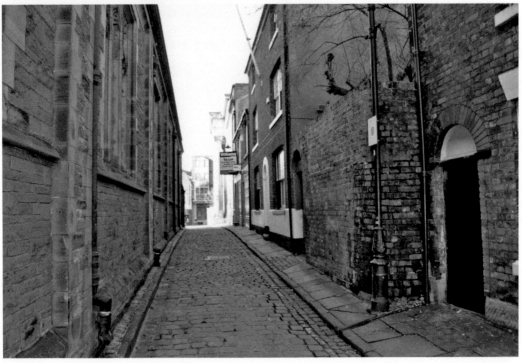

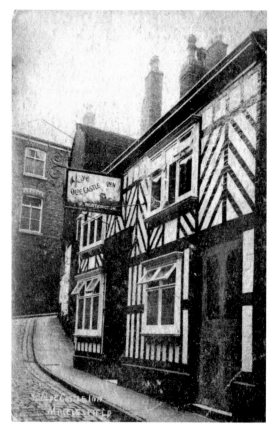

Ye Olde Castle Inn, early 1900s

This is what a British pub should look like. It is ancient and mainly un-altered both inside and out from those days long gone. It has a maze of small rooms with ornamental plaster ceilings. It is situated on the hill below the parish church and in these days of gastro pubs (although they do sell food) and child dominated play pubs, this is a beacon in the wilderness; fortunately Macclesfield boasts more than one true watering hole.

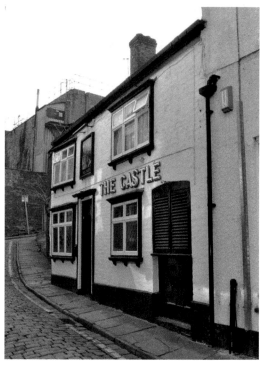

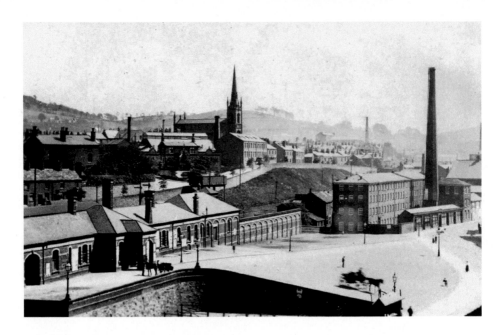

Macclesfield Station, late 1800s

A good match now as we look down at Central Station, now known as simply Macclesfield Station. In the centre of the old photograph is St Pauls church and this can be seen to the right in the modern shot. The old station buildings have been demolished to make way for more modern and attractive ones – oh alright, just more modern ones!

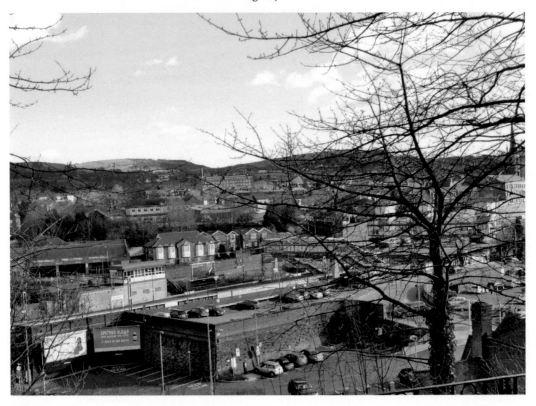

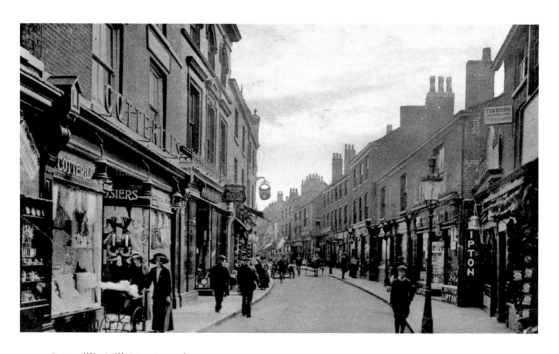

Cotterill's Mill Street, early 1900s

Now we walk from Market Place into Mill Street, the main shopping street in the town and one of the first shops is Cotterill's Hosiers, now re-built as the Santander bank.

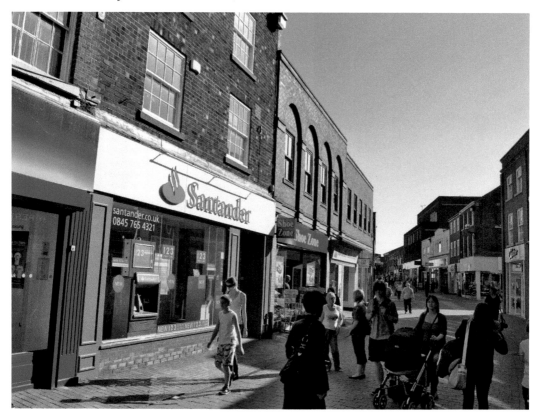

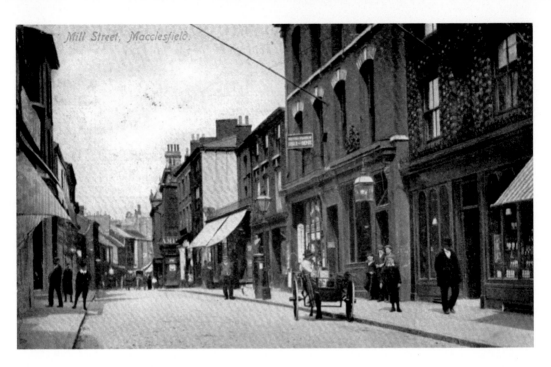

Mill Street, late 1800s early 1900s

While to its credit, many parts of Macclesfield are unchanged over the years. Mill Street is not one of them, at least at the top end. Fortunately this old photograph, taken at the turn of the last century remains unchanged in so far as the white building on the right in the modern shot is the same one as in the old one albeit that the flag pole has made way for a burglar alarm. The shop fronts have also been modernised.

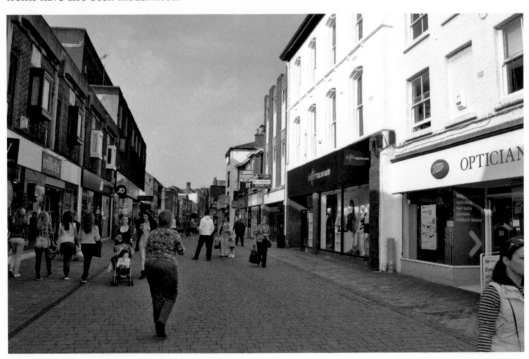

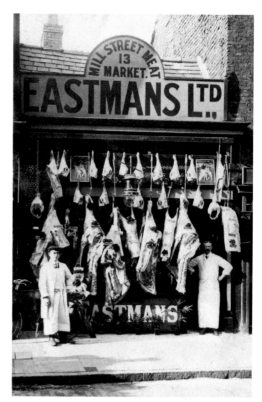

Eastmans, Mill Street, *c*. 1934
Now we have an example of the changes at the top end. Eastman's butchers at number 13 has gone, as has the building and its spot on Mill Lane. It has been taken over by a Dorothy Perkins shop.

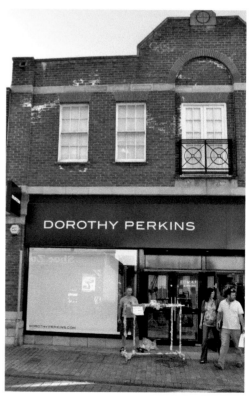

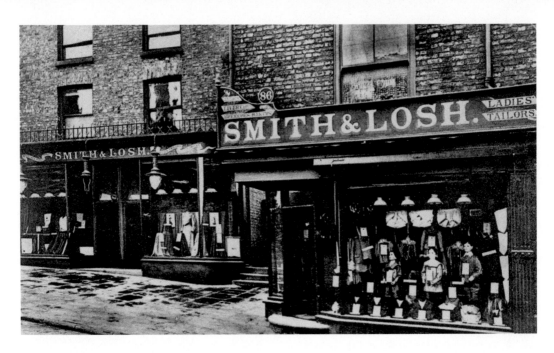

84 to 86 Mill Street *c*. 1910

In 1896 the shops situated at 84 and 86 Mill Street were occupied by Smith and Losh clothiers. By 1934 Harold Willdig a pork butcher traded from number 86 while number 84 housed Pullers of Perth, Dyers and Cleaners. Today, number 86 is a Scope charity shop. Number 84 spent time as a fruiterer but has now been demolished to make way for the bus station.

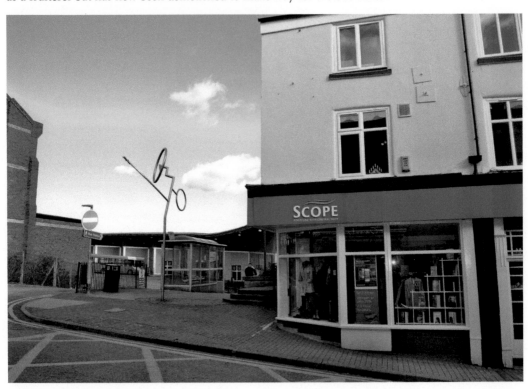

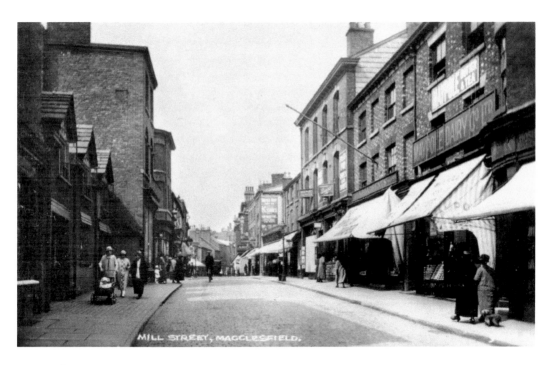

Mill Street, 1915–1920s
This is a view up Mill Street with the aforementioned white building on the right. As can be seen, much demolition and rebuilding has gone on here. The car about to negotiate lower Mill Street would date this photograph to the early 1920s.

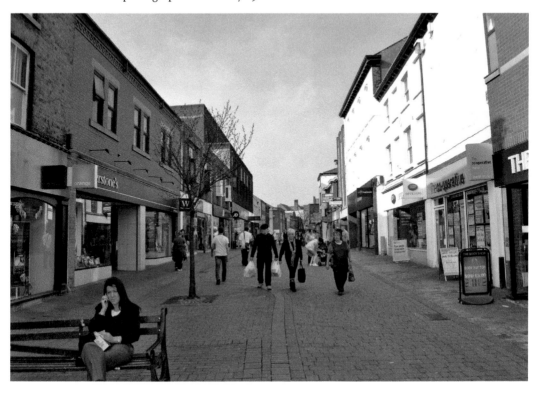

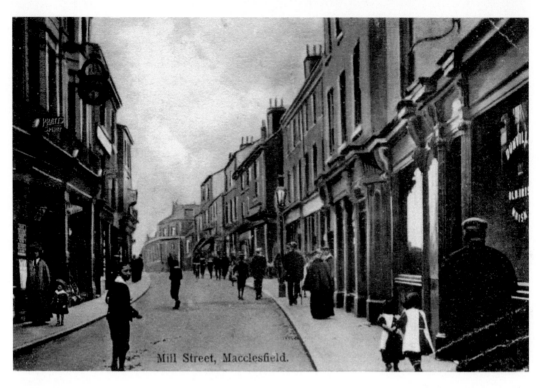

Mill Street, Macclesfield.

Mill Street, 1920s
It was very hard to replicate this old photograph with certainty so feel free to identify the scene.

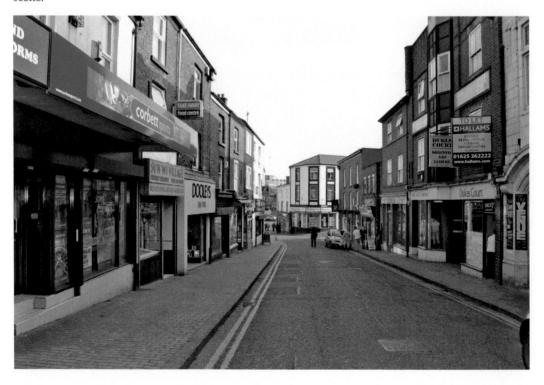

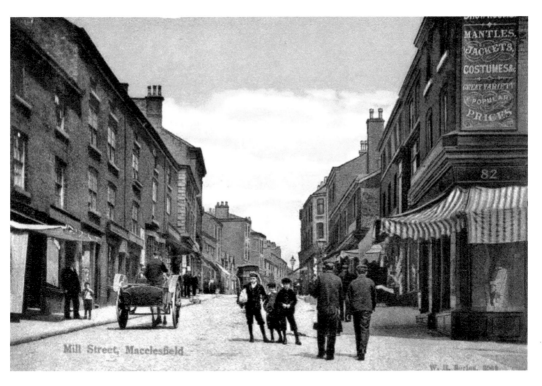

Mill Street, *c.* 1900

Unlike the last one, this one has many similarities, apart from the building on the left still being *in situ*, the more modern buildings have been built in a similar way to those they replaced.

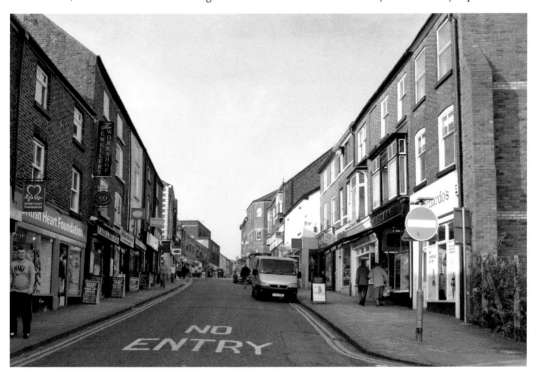

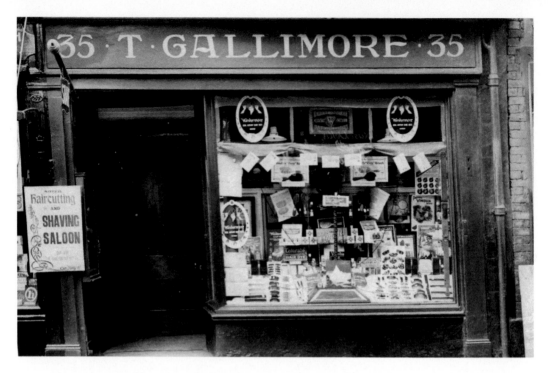

T. Gallimore, 35 Mill Street, *c.* 1934

T. Gallimore was a barber shop at 35 Mill Street. Hairdressing was in the family as William Gallimore had a salon in Commercial Road in 1880. He was still there in 1901 when Thomas Gallimore is also shown at 35 Mill Street. Thomas was a hairdresser of long standing as he was still at this shop in 1934. Marks & Spencer now occupies the site.

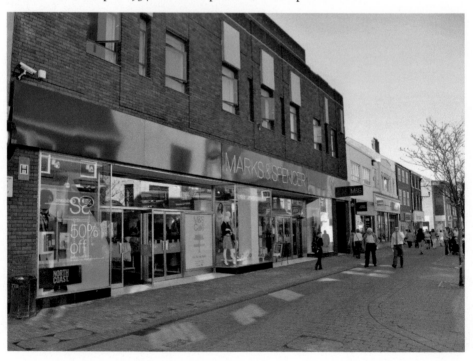

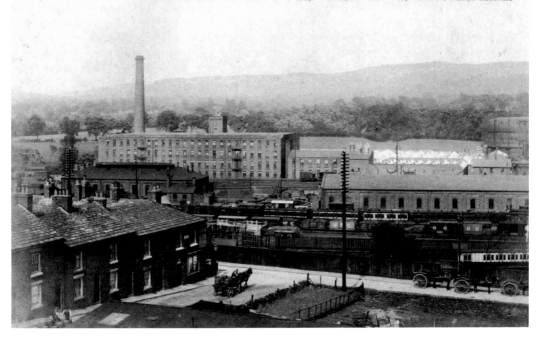

Hibel Road Station, *c.* 1900

The view from the top of the hill is quite hard to replicate due to access problems but this one is not too far out and the old late 1800s photograph is excellent. We look across the railway to what was once the mill buildings and later the short lived Victoria Park flats. They were built in the awful period of architecture and became a blot on the landscape. The lovely old photograph shows the wagons and carriages between Hibel Road and the Central stations. The 'GC' on the wagons stands for Great Central.

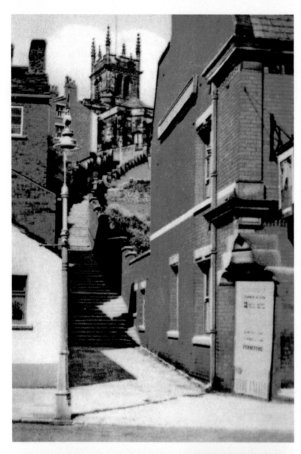

108 Steps, Undated
These steps take the pedestrian from St Michael's church down to Waters Green. They are quite steep and the more fit residents use them to jog up. The age of the steps is unknown, but it is believed that they pre-date 1700.

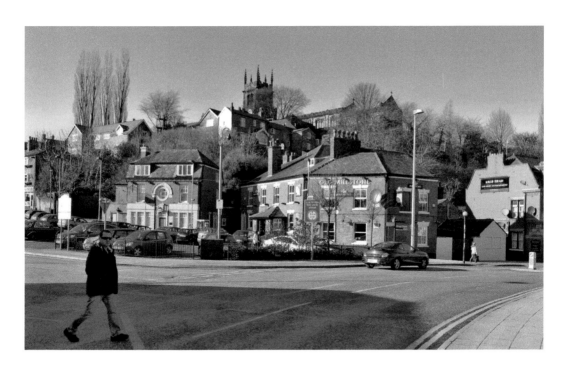

Waters Green, 1930–1940

This very pleasantly named area of Macclesfield has always been a favourite gathering place with its assorted and cosy public houses. There was a sheep and cattle market here until the 1980s and the Macclesfield workhouse was also situated nearby. In these two photographs, the reader can just become immersed in old Macclesfield with so many things that have not changed to compare and enjoy. The building of the pub with the round window is displayed in the West Park museum.

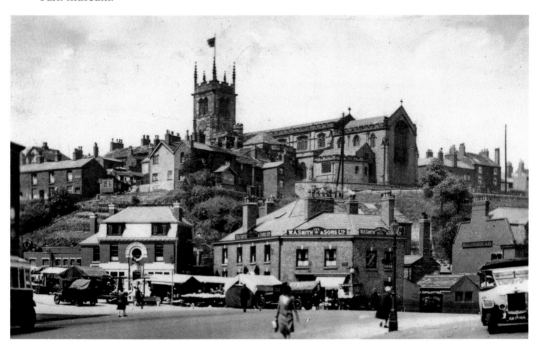

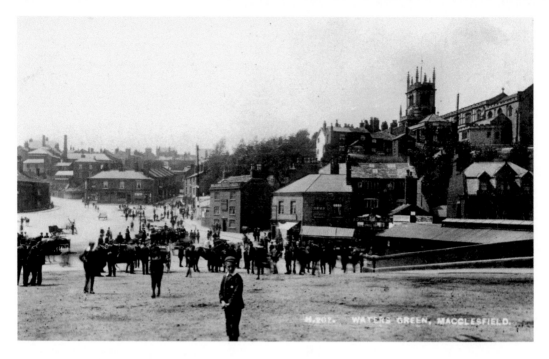

Waters Green, late 1800s

Another look at this area with an old and atmospheric photograph that was taken from Macclesfield Central as it was known then. This pair also highlights just how the internal combustion engine has had such a big effect upon our lives.

The 108 steps can be seen beneath the church tower.

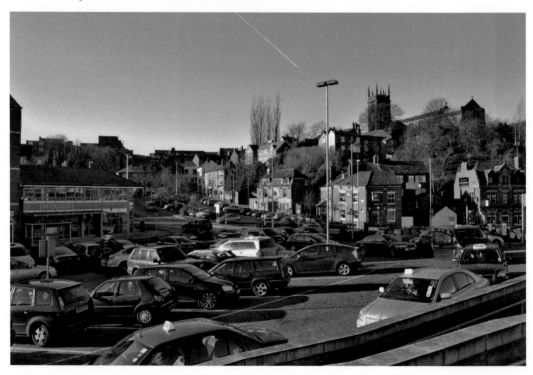

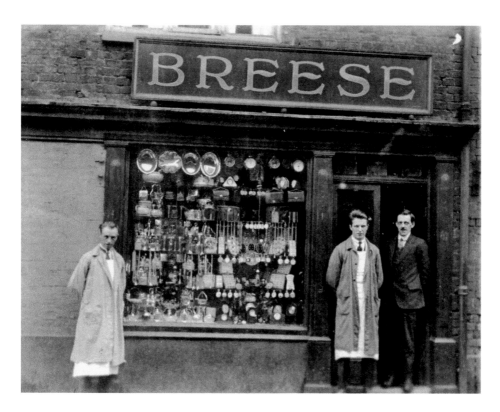

Breese Shop, 64A Sunderland Street, *c.* 1935

This wireless and watchmaker's shop owned by Albert Breese was situated at 64A Sunderland Street. As can be seen by the modern photograph, this would have been situated on the car park at the side of the Snowgoose bar.

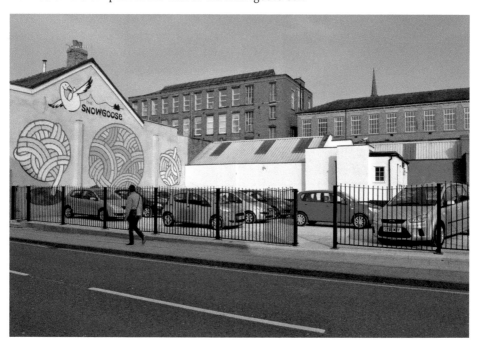

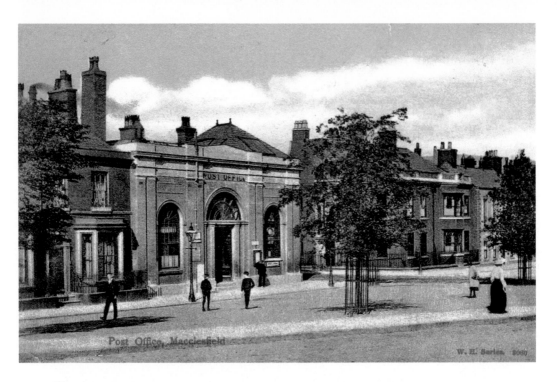

Post Office, late 1800s

Now in the Park Green area you see the changes that have taken place over the years, specifically the post office building. This was, at the time of the photograph, around the turn of the century, the main post office with branches around the town. It was open daily from 8 a.m. to 10 p.m. for stamps, postal orders and registration letters. Sunday hours were from 8 a.m. to 10 a.m. but postal orders could not be sold on a Sunday. Neil Daniel Stewart was the postmaster.

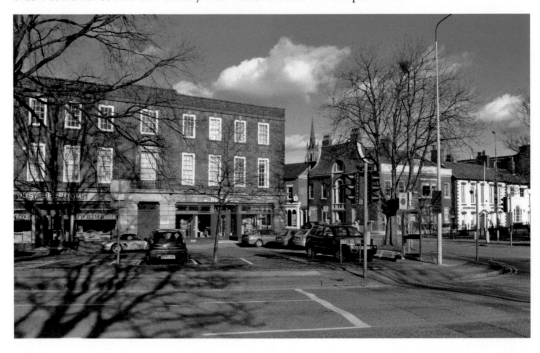

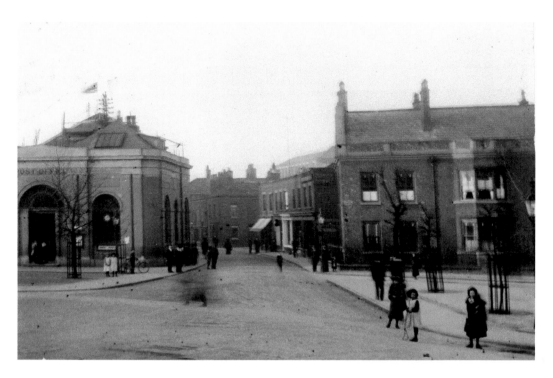

Into Sunderland Street, *c.* 1900

Here we look from Park Green into Sunderland Street with the library on the left in the old and sadly quite poor photograph. The building that replaced it went through various uses; the one that I remember was as the magistrates' court. On one occasion I had to vault into the dock to restrain a prisoner! Apart from the post office building, there has not been much change here over the years.

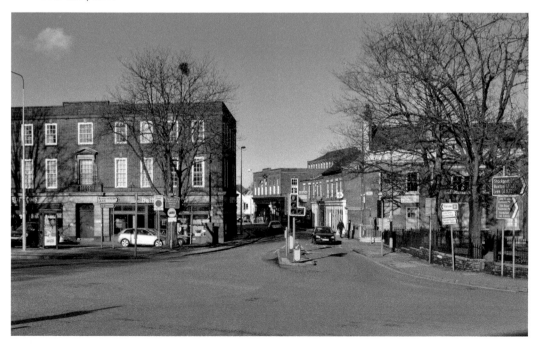

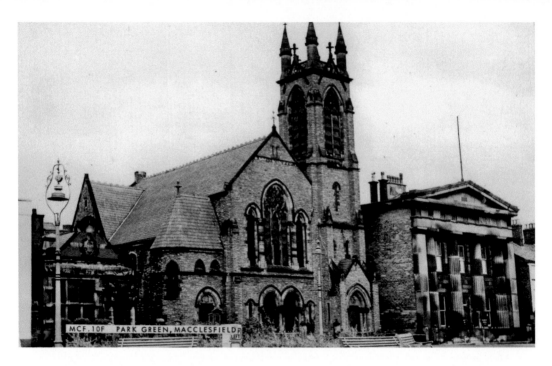

Park Green Church, Undated

A look now at the Palladian style building and the church. Now known as Macclesfield United Reformed church, it was built in 1877 as The Congregational Chapel, Park Green, having been founded in 1787 in Townley Street. When this new chapel was built the original place became a Sunday school. The attractive building next door was a bank for many years under assorted banking names, mainly Martins Bank and in 1891 it was the Adelphi Bank.

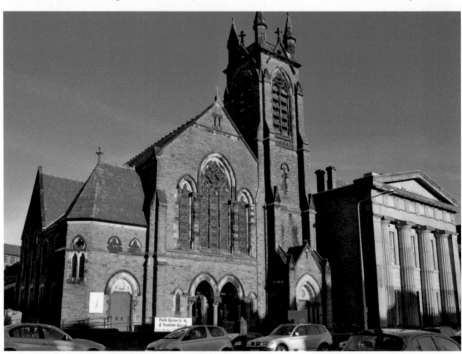

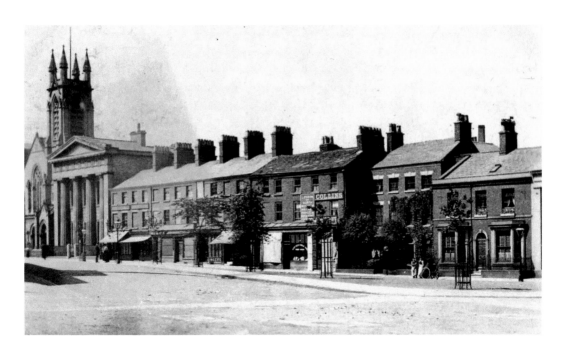

Park Green, *c.* 1900

Here we look back towards the church, from the Park Street junction the buildings have either been replaced or vastly modernised. What an atmospheric photograph the old one is, horse manure is spread liberally on the road in this turn of the century snapshot in time. The Collins building also has a board stating that it is the LNWR parcels receiving office. That is number 28 Park Green and Walter Collins was a stationers' as well as an agent for the LNWR.

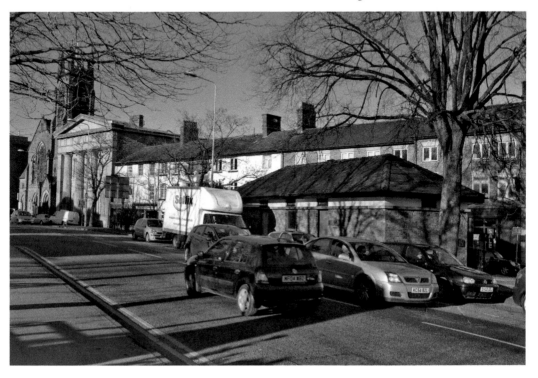

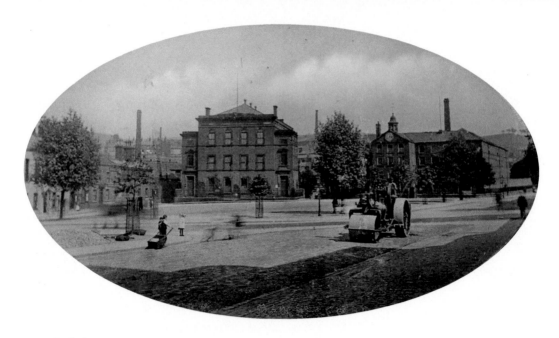

Park Green, 1915–1920s

In this oval postcard inset we can see that it is pre-1922 as the war memorial is still to be erected. It will be erected on this open space as we look towards the area from Park Green. A steam roller makes its way sedately towards Mill Street, possibly working on the road and the large building in the distance is still there, although the mill with the clock next to it has gone. The old photograph is from a decorated postcard popular at the time and some of the young trees have reached maturity safely.

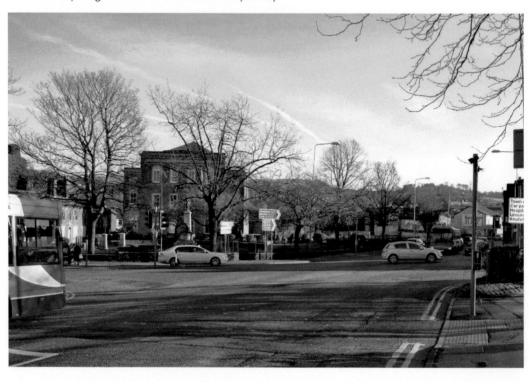

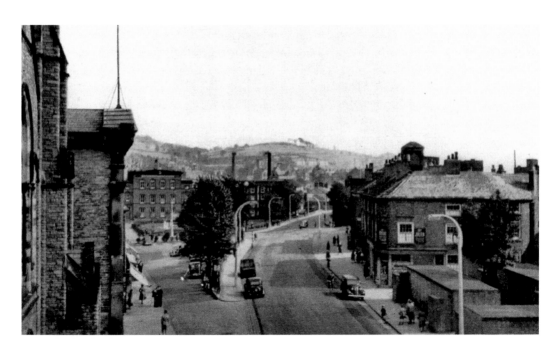

Park Green, 1940–1950

The first silk mill was opened in Park Green in 1756 by Charles Roe, hence the main street adjoining it is called Mill Street. This photograph dating from around the 1950s was taken from an elevated position that I could not match but you can get an idea of the changes that have taken place here since that period. The now demolished mill chimney discharges black smoke and most of the buildings on the right have been swept away.

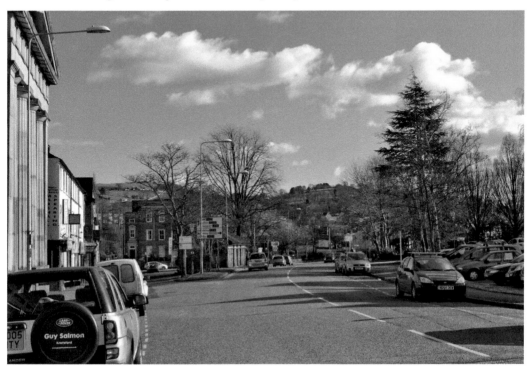

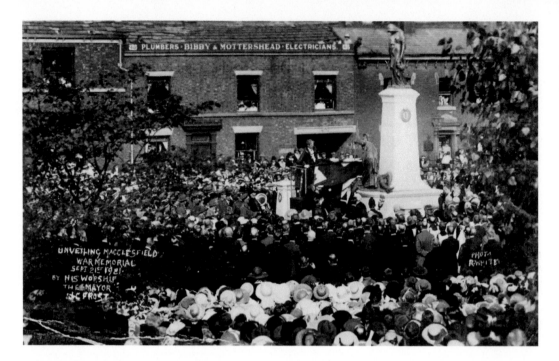

Unveiling The War Memorial, 1921

This memorial to those who fell in the First World War was unveiled by J. C. Frost, the mayor of Macclesfield on the 21 September 1921. The crowds gather and the band plays. Little did they know that less than twenty years in the future the Second World War would start and more names would be added to the memorial – and are sadly still being added.

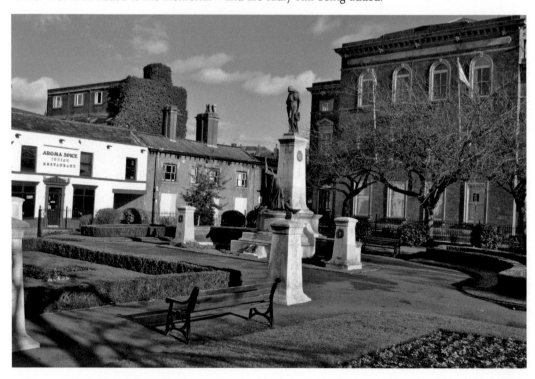

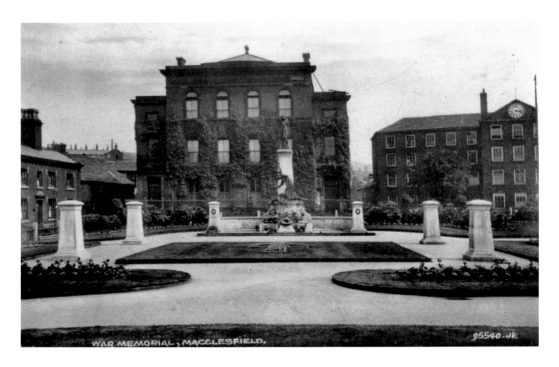

War Memorial, 1920s

Here we see the war memorial shortly after being unveiled and the main column with the two stone plinths at either end of the curved wall. Each one carries a bronze inscribed plate. Four freestanding pillars bear the names of the dead of Macclesfield. Over the years and up to today, we owe our service men and women so very much.

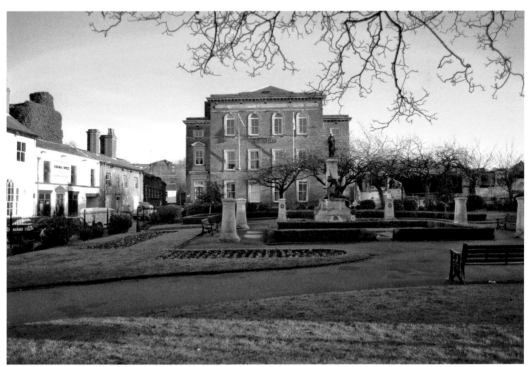

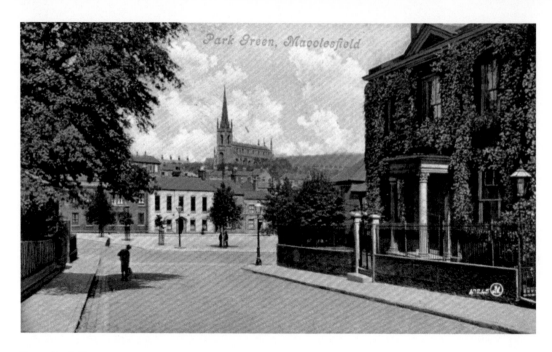

From Park Street, c. 1900

There have been many changes at this location over the years with the end of Park Lane dissected for the purpose. We stand in Park Street looking into Park Green and towards Sunderland Street, across the war memorial to the church of St Pauls in Glegg Street. The church was built in 1844 at a cost of £5,400 and has a commanding view over the town. The old photograph is hand tinted and was taken in the days before the war memorial gardens.

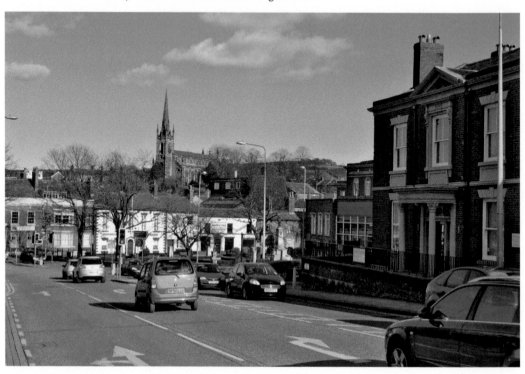

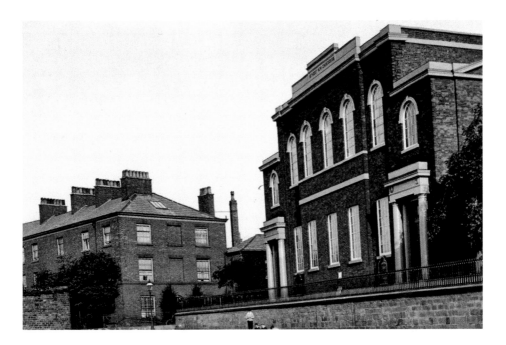

Park Street Chapel, *c.* 1900

Into Park Street now and looking towards the new roundabout at Churchill Way and thence Park Green, we find the Park Street chapel. This area is where Park Lane becomes Park Street. The chapel was built in 1836 and opened in 1837 as the Methodist New Connexion chapel. The words can be seen on the raised ornamentation at the front of the roof; it cost £4,500 in total and is now no longer a chapel but has been converted into apartments.

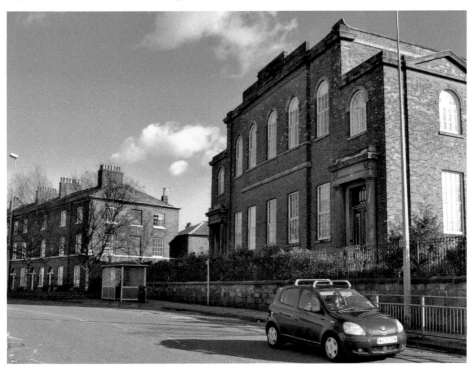

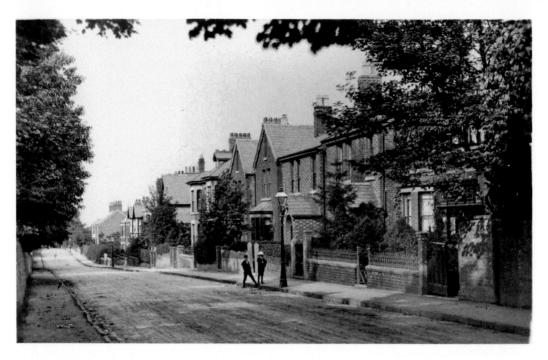

Oxford Road, early 1900s

Another residential street here that has changed very little over the years and the old photograph is a particularly good one. Now a major route towards Congleton, at the time of the old photograph sometime at the turn of the last century, it was so different. The dirt road and the same houses, only then were devoid of modern appliances with nothing to interfere with the peace and tranquillity. The houses are of a good quality and would have been comfortable.

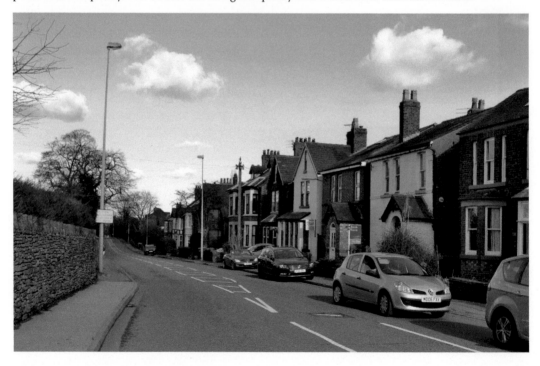

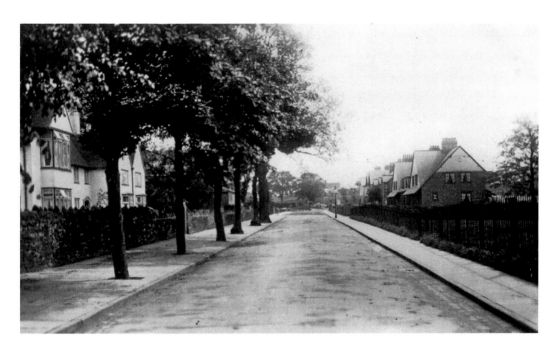

Ryles Park Road, Undated

Another suburban street named after a local benefactor and mill owner, Ryles Park Road joins The Ryles Park, Ryles Arms, Ryles Park Girls School, the Ryles canal etc. John Ryle is known as 'The father of the silk industry'. He was born in Bollington on the 22 October 1817 and later moved to the USA.

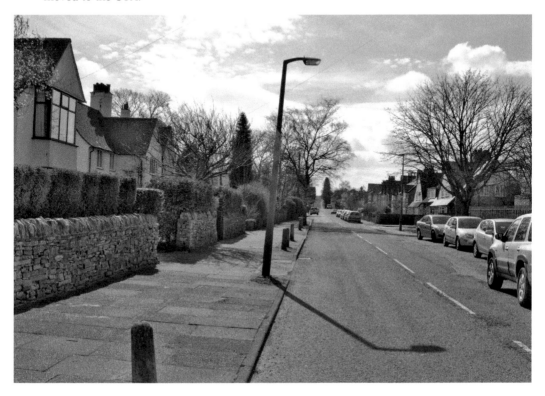

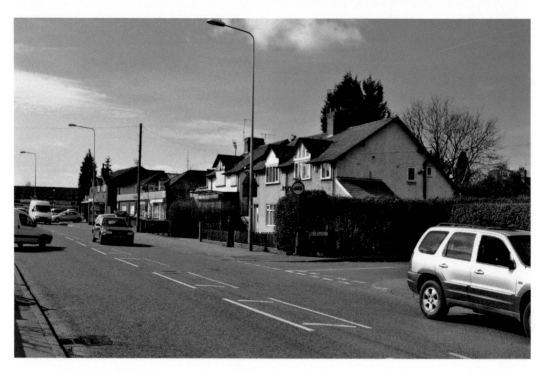

London Road, 1930–1940
Here we see London Road at its junction with Lyme Avenue. The large building in the far distance in the old photograph has now gone and the Moss Rose football ground, home of Macclesfield Town FC is in that location.

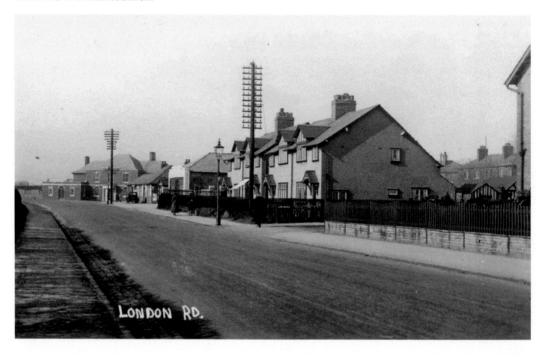

LONDON RD.

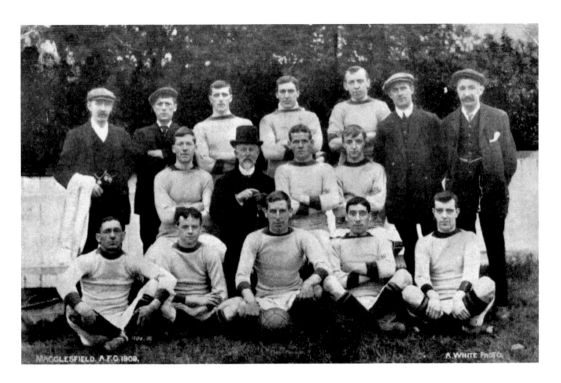

Macclesfield AFC, 1909

The team was formed in 1874 and the club was known by a succession of names, including Macclesfield Football & Athletic Club and Hallifield FC. Then after the Second World War, Macclesfield Town Football Club Ltd. was formed and the club gained their current name. They are at present the longest serving team in Football League Two. The photographs compare the 1909 team with the current one.

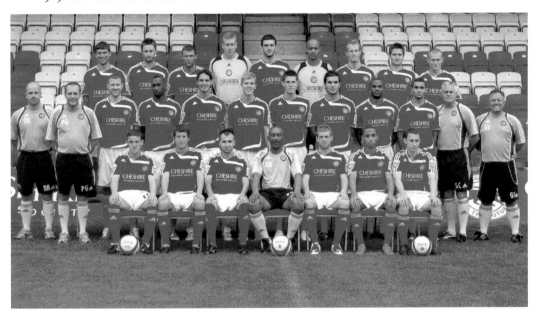

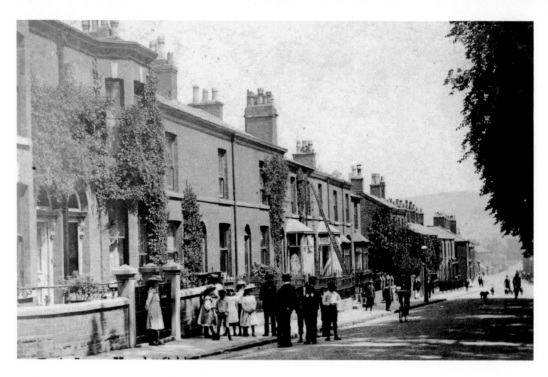

Park Lane, early 1900s

Now we go up Park Lane to the road into South Park and look back. The house with the bay windows on the left has lost its coat of ivy but the gate posts are still there. The iron railings in the road have been taken for the war effort leaving a more modern one on this house. The house next door nearest the camera has had alterations to turn it from a dwelling house into a shop and the front door has been relocated as you can see.

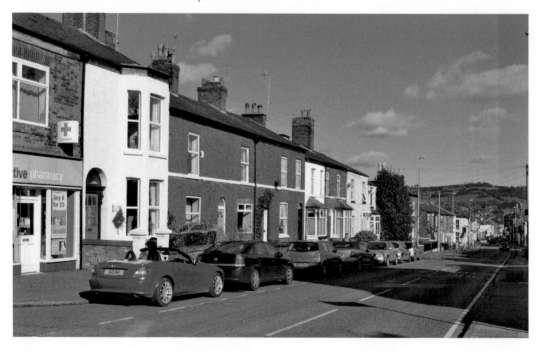

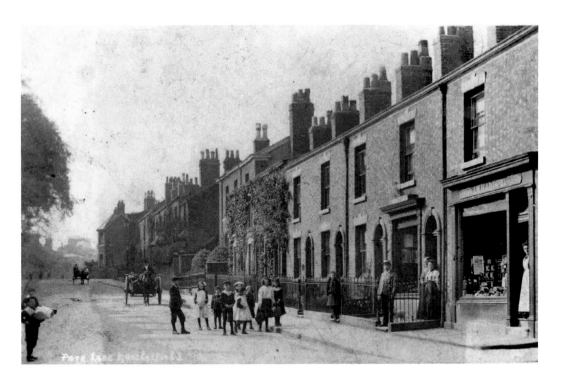

Park Lane, *c.* 1910

Once a busy shopping area, this road has become mainly residential. Situated nearby is South Park. This was once a haven of Victorian charm, now more of a modern play area. The road itself stretches between Congleton Road and the town centre. The turn of the century photograph features shops that are now residential houses, the first having been rendered. Although there is a Harding listed in Park Lane at the time, it is as a watchmaker and tobacconist with a different address.

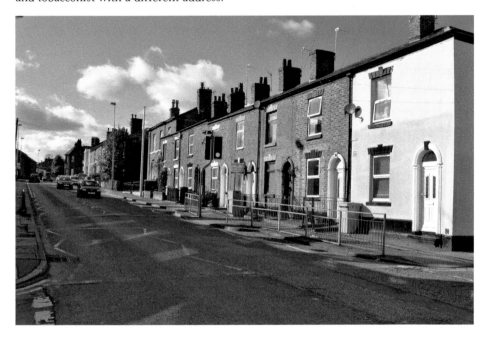

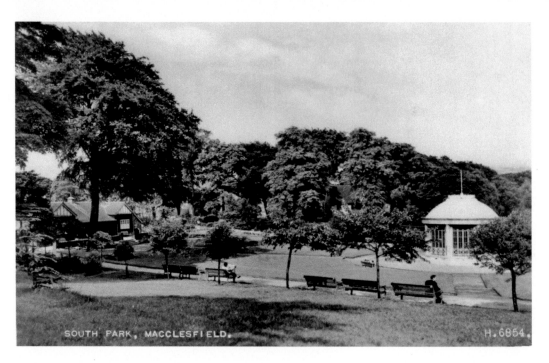

South Park Macclesfield, Undated

It was difficult again to get an exactly matched pair of photographs here as the park has changed so much from the heady days of Victorian charm to the current practical requirements. In those far gone days the band would play regularly on the bandstand shown in the old photograph.

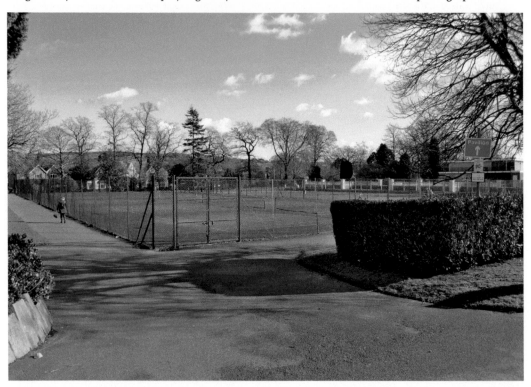

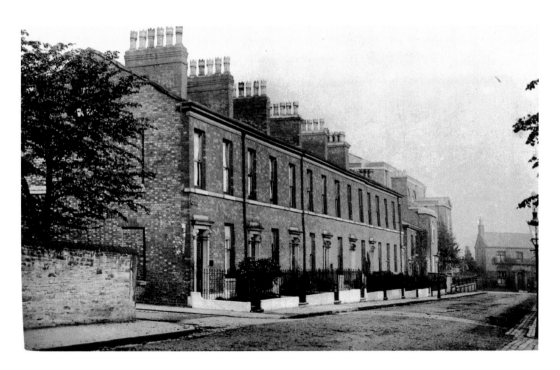

High Street, *c.* 1900

In most towns the high street is filled with shops and is the main road in the town. In Macclesfield it is a haven of quiet with its old terrace of good class dwelling houses, terraced houses and courts. It is also a remarkably well kept area where the local residents have joined with the council and other agencies to make their streets and houses a perfect example of good management. A blue plaque was erected to celebrate this and it can be seen in the inset.

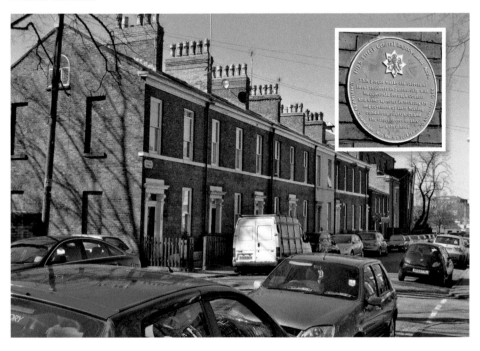

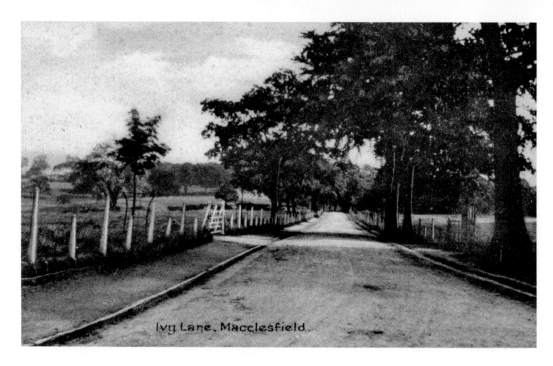

Ivy Lane, Macclesfield.

Ivy Lane, 1800s

This once quiet lane leads from Chester Road through to the junction with Park Lane, Congleton Road and Oxford Road. From Chester Road to this location, the road is called Ivy Road, changing to Ivy Lane here. In the old photograph, the lane passes through open country but is now lined with residential houses. The large tree on the left is almost certainly the tree just past the gate in the old photograph. I would estimate that this was taken in the late 1800s.

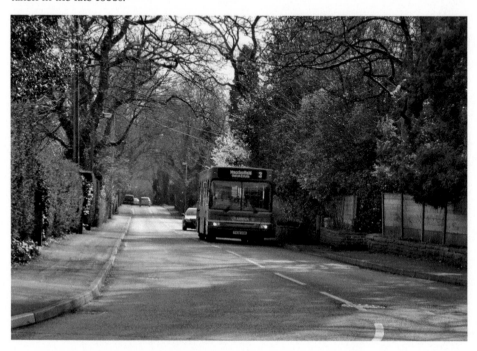

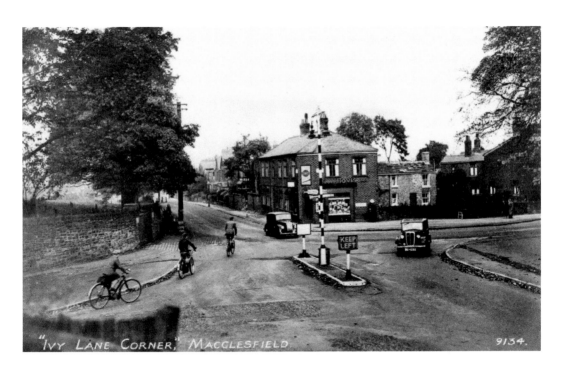

"IVY LANE CORNER," MACCLESFIELD 9134.

Ivy Lane, 1940–1950s

This is the location as described on the old photograph which dates from the late 1930s to 1940s. It is not, however, a corner, but a cross roads with the cycles coming out of Ivy Lane. Park Lane would then be straight on and Oxford Road to their left with Congleton Road behind the camera. Much road widening has been carried out here and the large shop has gone, although the houses behind it are still there.

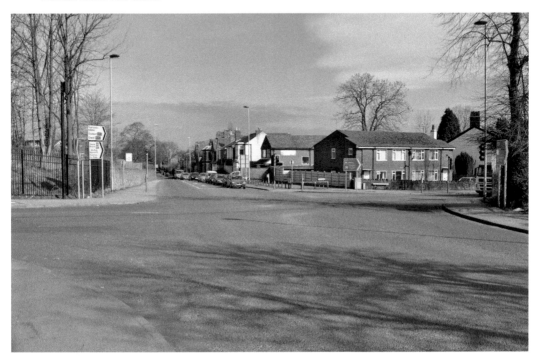

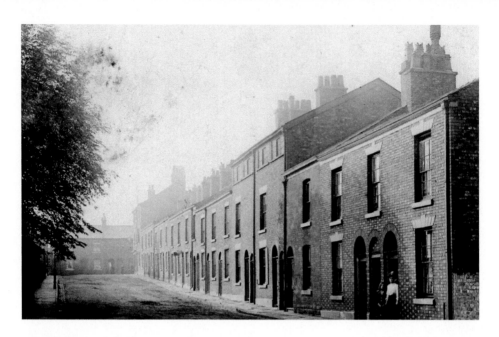

James Street, c. 1900

This suburban street has at some time been the scene of a cottage industry. I say that because of the high house in the centre. The top will have been at one time a workshop or similar. This was a common practice at the time these houses were built. But I welcome advice as far as this building is concerned.

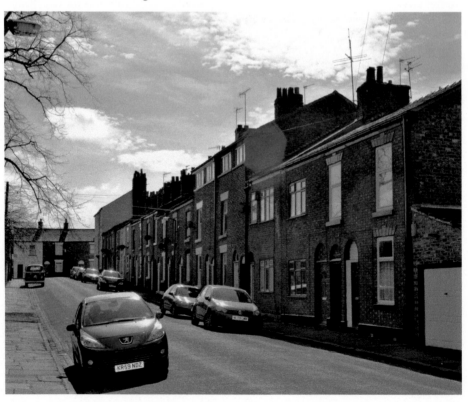

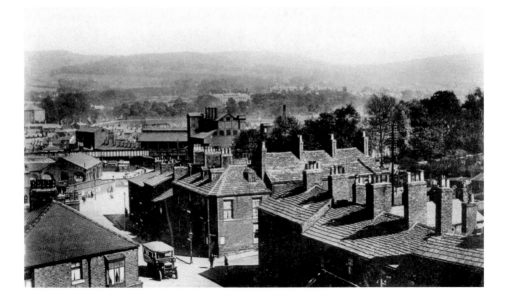

Hibel Road, *c.* 1920

Unfortunately I could not replicate this shot perfectly as I could not get high enough. If you look at the corner of the roof on the far left you can see that it is shown in more detail in the modern photograph. Further down on the left some goods vans can be seen in the old Hibel Road station. This station was built on the 13 June 1849 by the LNWR and in 1871 a new station was built by the North Staffordshire Railway called Macclesfield Central. The NSR and the LNWR did not work together but both stations remained open until 1960 when British Railways closed Hibel Road and called the Central Station simply Macclesfield. Hibel Road station has now disappeared.

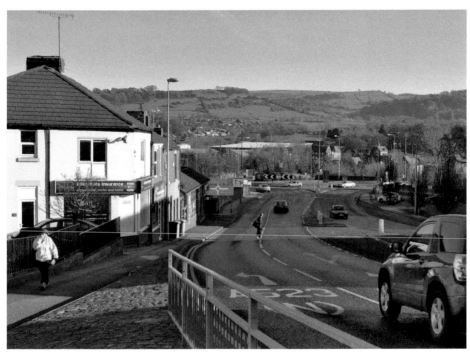

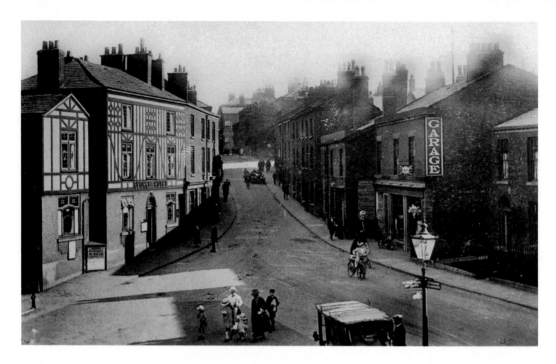

Jordangate, 1920s

We now look at Jordangate from Hibel Road, I could not get as high as the photographer who took the old photograph but as you can see, it is filled with 1920s charm, from the old car coming down the hill to the man about to board a taxi that was 'old' even then. The George Hotel has lost its decorative wood cladding and is in fact no longer a hotel or pub having gone the way of many of its peers. The multi-storey car park was a garage and petrol station in those long gone days.

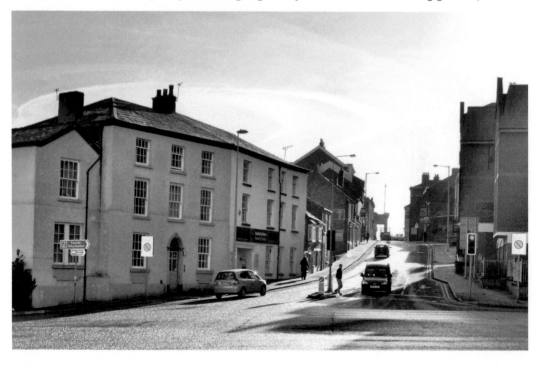

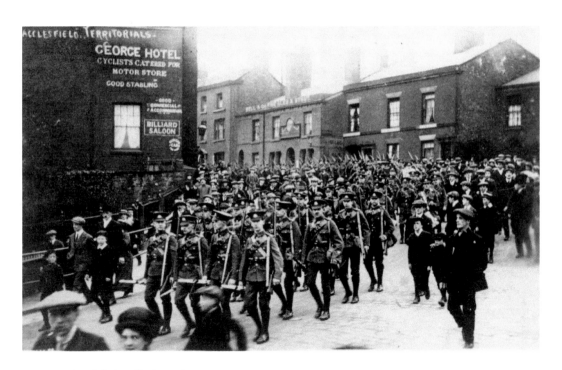

Territorials in Hibel Road, *c.* 1915

This is a scene replicated all over the UK in these dark days of the First World War. Groups joined together to form battalions to go and fight. Some were called 'Pals Battalions' and joined with the territorials; hence when there was a high loss of life in a battle that they took part in, it affected their home town so much more. In this case they will be marching from the town centre to Hibel Road station to entrain for their barracks. The townsfolk have gathered to give them a good send off.

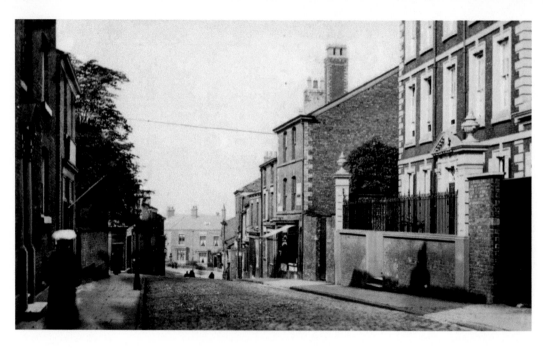

Jordangate, *c.* 1900

This old photograph will have been taken *c.* 1890 and shows a lady in period dress walking down towards Hibel Road. The large building on the right is Jordangate House, once called Pear Tree House and it was built in 1728. The Jordangate was one of the town gates and it led down to the River Bollin which in early deeds is shown as the River Jordan. This is one reason for the name, but not the only one.

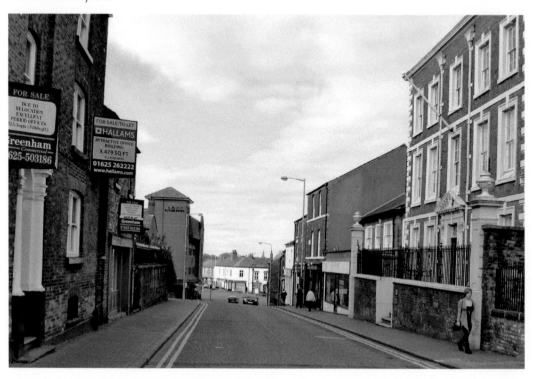

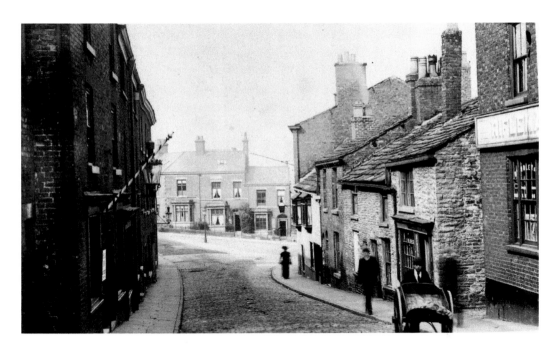

Jordangate into Hibel Road, *c.* 1900

In this photograph we see Jordangate which was one of the ancient gates through the walls into the town. The walls are long gone but the names remain. The old cottages on the right have been thinned out and the houses on the left demolished to make way for a multi-storey car park. Strangely the building on the right seems to be The Rifleman but I can find no record of a pub with this name in Macclesfield.

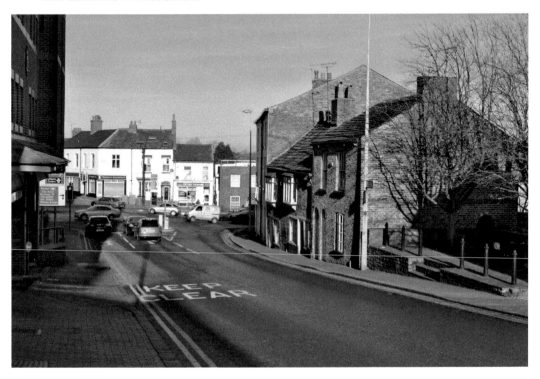

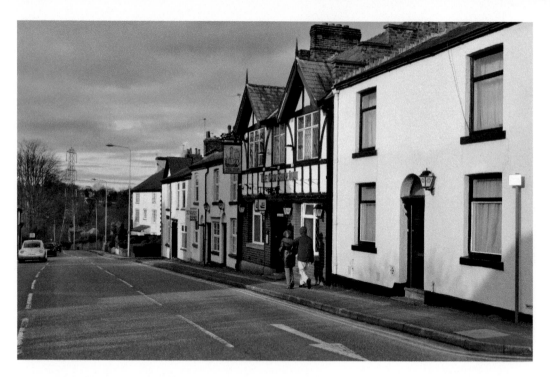

Old Ship Beech Lane, early 1900s

Here we look down Beech Lane, away from Hibel Road. On the right is the Old Ship Inn. I can find no record of this pub at the time of the old photograph despite searching numerous directories, but in 1934 Terence Nolan was listed at number 63 as a beer retailer. The pub has since incorporated number 61 as an extension. It is a cosy establishment with open fires in winter.

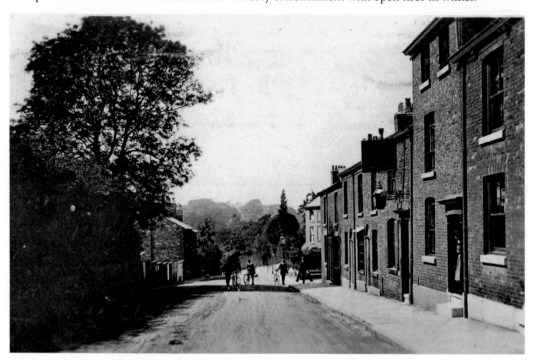

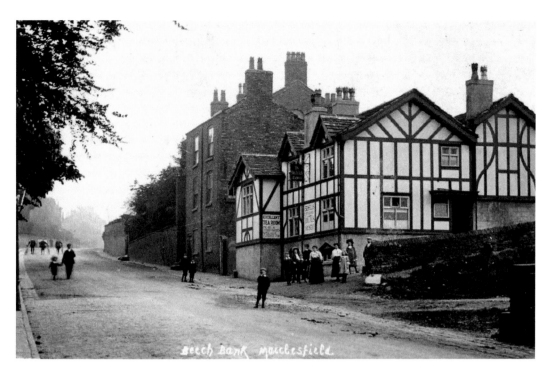

Beech Bank, 1900s

The old photograph here shows Ye Beech Bank Tavern in Beech Lane. During the latter part of the nineteenth century the Pyatt family resided here and many more of the family lived at Beech Cottage nearby. Today it houses the beauty treatment emporium Fablounge.

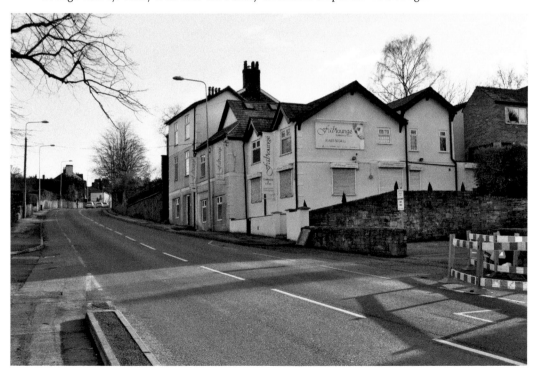

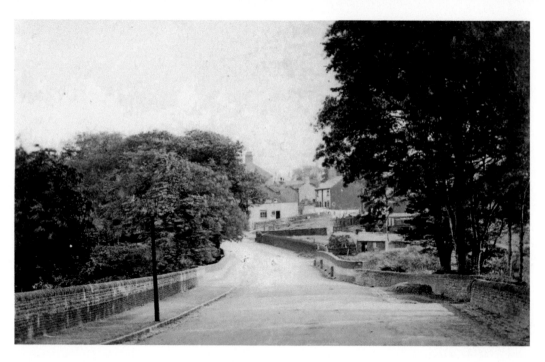

Beech Lane, Undated

In the foreground can be seen the bridge over the fledgling River Bollin as it sets off towards the River Mersey and Manchester ship canal. In the new photograph, the bridge is under repair. Macclesfield railway station was opened in Beech Lane by the LNWR on 19 June 1849, but just a month later was moved to Hibel Road. The Hibel Road rail tunnel is beneath this road taking the rail from Macclesfield to Prestbury stations.

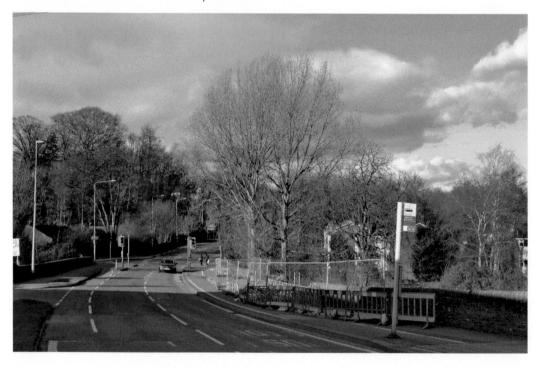

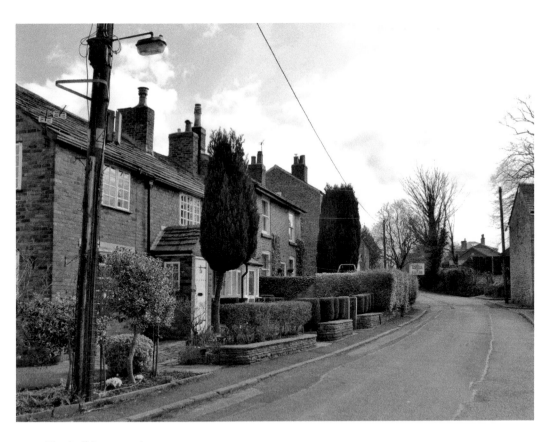

Bluebell Lane, early 1900s
This is a simple pair of photographs showing a quiet and picturesque lane in Tytherington.

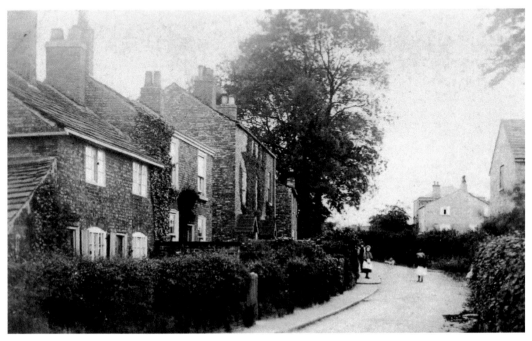

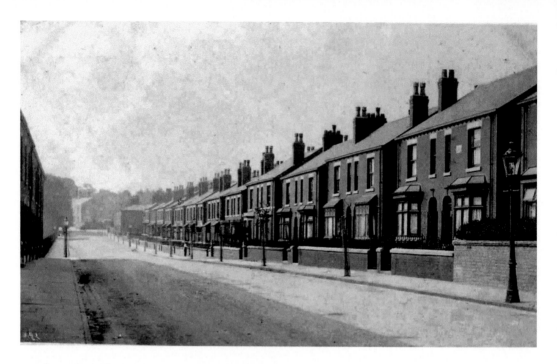

Bond Street, early 1900s

A few examples of a suburban street now, with old and new photographs of Bond Street. Here we look towards the Shaw Street junction. At the first house on the left with the plaque on the front, the photograph is undated but you can see the newly planted tree in the old photograph and that it is still there in the new – although slightly larger. It also appears to be the only one to survive the ravages that the years between have seen.

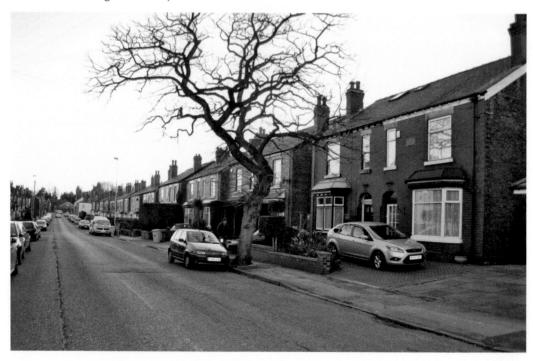

Bond Street, Undated

We now go to the other end of the road and look back to see what has changed. The first house is detached and has lost its leaded glass to more modern double glazing. Then there are four sets of semi-detached houses followed by a gap in the houses, which, by the time of the modern photograph, has been built on.

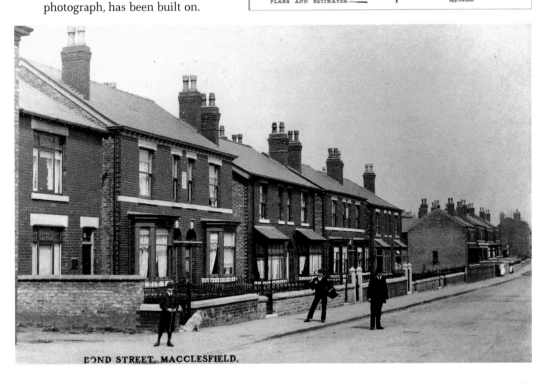

BOND STREET, MACCLESFIELD.

71

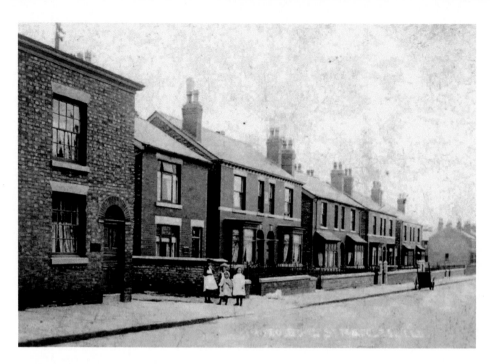

Bond Street, early 1900s

With two nice old photographs, albeit they are similar views, I will use both with one new one and take this opportunity to include a set of period advertisements.

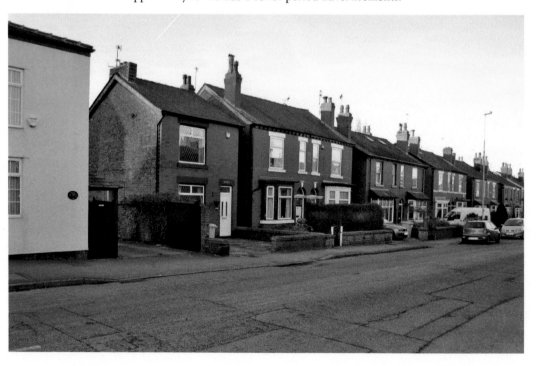

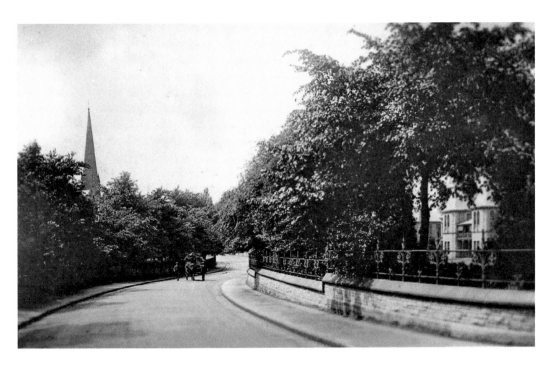

Cumberland Street, early 1900s

A little difficult to pinpoint this area due to the vast amount of change to facilitate the new hospital so you will have to make up your own mind whether I have got this one right or not.

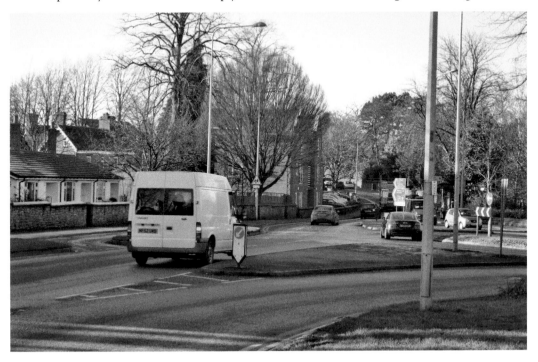

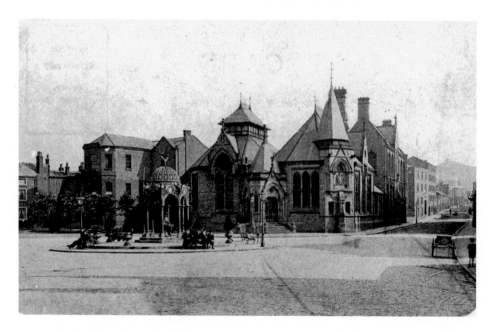

Chadwick Free Library, early 1900s

The library situated in Park Green (Southside), was presented to the town in 1876 by Mr David Chadwick of Dulwich who was one of the two MPs for Macclesfield from 1868 to 1880. The other was William Coare Brocklehurst, a mill owner. It was designed by Mr James Stevens of Macclesfield who also designed the nearby School of Art which opened three years later. Of the 16,873 volumes in the library in 1896, 10,000 were a gift from Mr Chadwick.

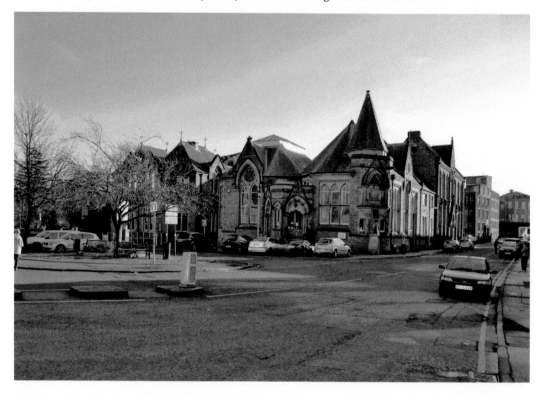

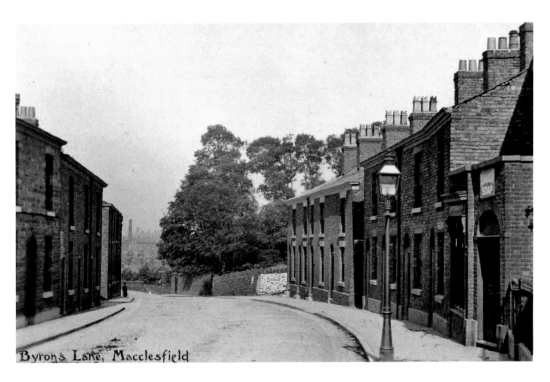

Byrons Lane, Macclesfield

Byrons Lane, early 1900s

This lane leads from the town to Hall Lane by the canal when the name changes. In this set of photographs we look back towards Macclesfield at the terraced cottages that have long stood at this location. As you can see, number 46 is no longer a shop selling Sunlight soap.

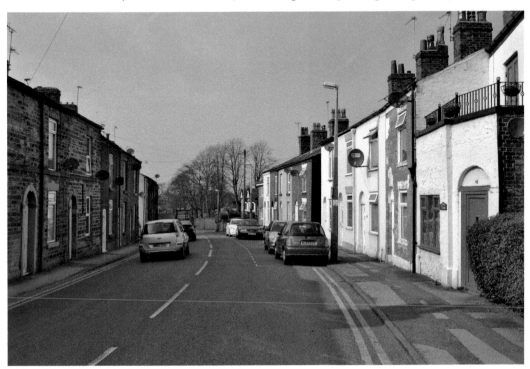

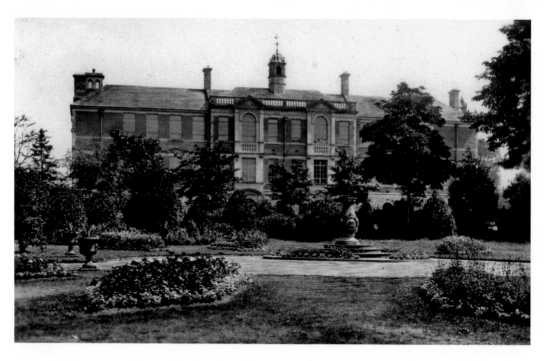

High School for Girls, Undated

This school opened its doors to the girls of Macclesfield in February 1909 and in 1980 became a mixed state comprehensive. It remained open until 1990 when it was forced to close. This beautiful building was then left in a neglected state for two years until taken over by the Kings School Foundation. It is now the girls' division of the Kings School.

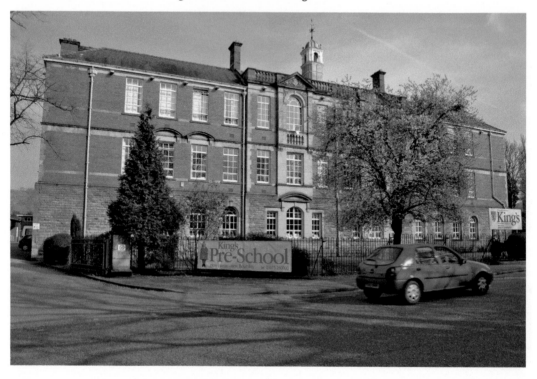

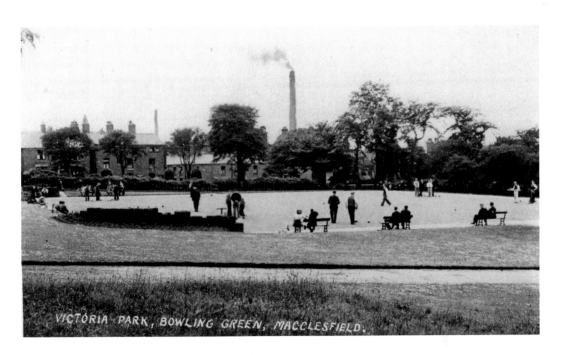

Victoria Park Bowling Green, Undated

Here we have a photograph of the bowling green which is undated. Victoria Park opened in 1894, not long before the girls' school over the road. This photograph shows the bowling green in the park and the man in the picture is an old Macclesfield resident by the name of Frank Talbot. Mr Talbot was able to give me a potted history of the area and for that I am grateful.

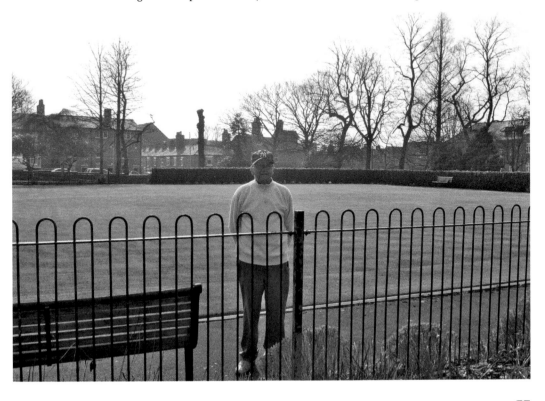

Thorp Street Mill, 1920s
This old silk mill is accessed under the railway tunnel from Gas Road and Waters Green. It was built around 1825 and is now a Grade II listed building, used for light industry.

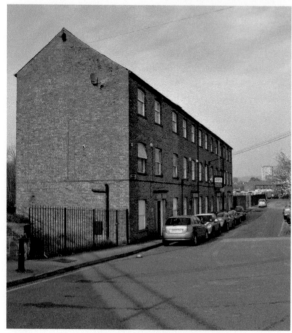

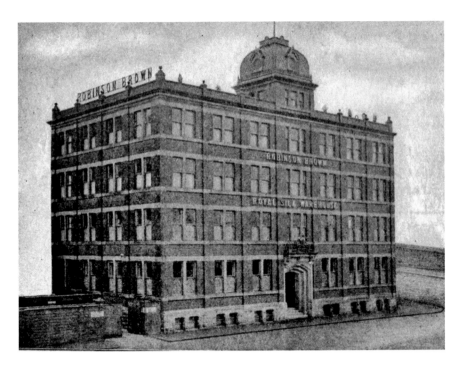

Royal Silk Warehouse, *c.* 1900

This building was built in 1903 and bears the date stone RB 1903. It was a silk warehouse, not a factory and its products were sold around the world. It went through various different concerns until the new millennium when, from 2008 to 2009, it was extended and converted into a Travelodge Hotel. The old photograph is from an advertisement for its products.

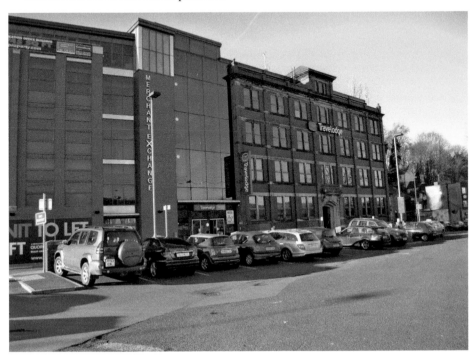

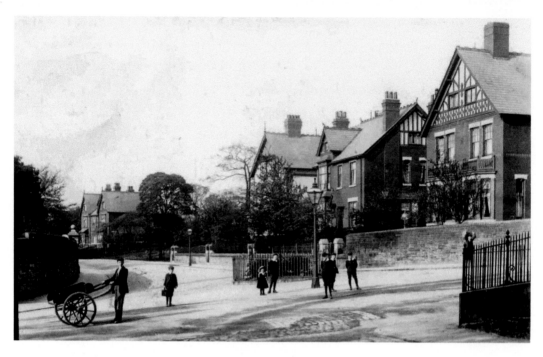

Buxton Road/Fence Avenue, *c.* early late 1800s to 1900s
Here we see the junction of these two roads, further along Fence Avenue the girls' school can be seen in the new photograph. It is not in the old one so the photograph will be pre-1909. There has been little in the way of change at this location.

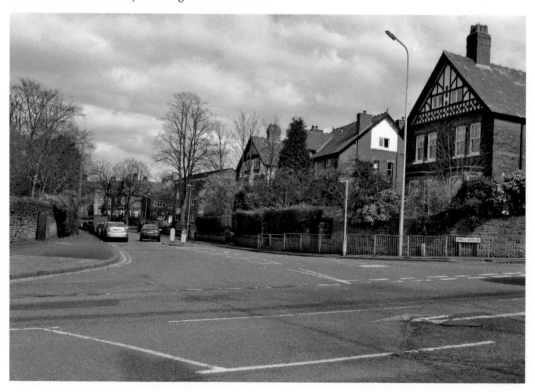

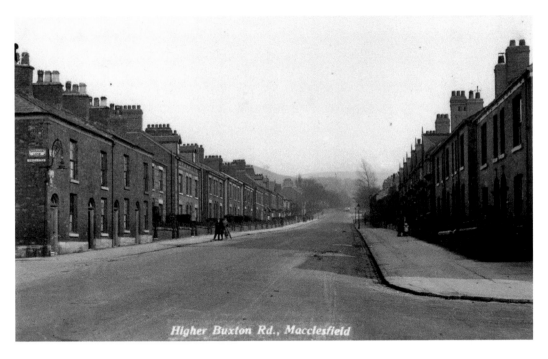

Higher Buxton Road, 1940s–1950s
Continuing up Higher Buxton Road, in the direction of Buxton and the Cheshire Peak District through which you will travel to get there.

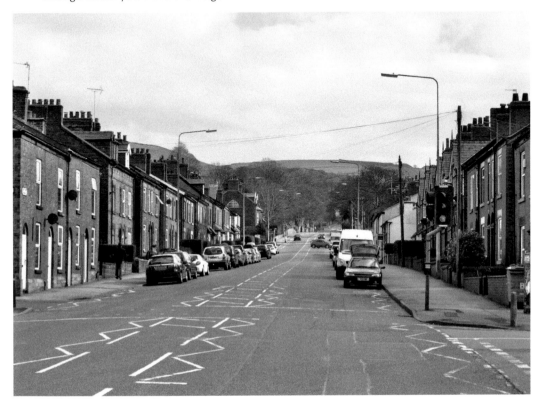

Hurdsfield Sunday School, early 1900s

This attractive building was built as a non-denominational Sunday School in 1811 and was enlarged and improved in 1833. It is still in use as a Sunday School and church. Little has changed in the 169 intervening years, at least to the outside of the building, apart that is for a sloping porch roof.

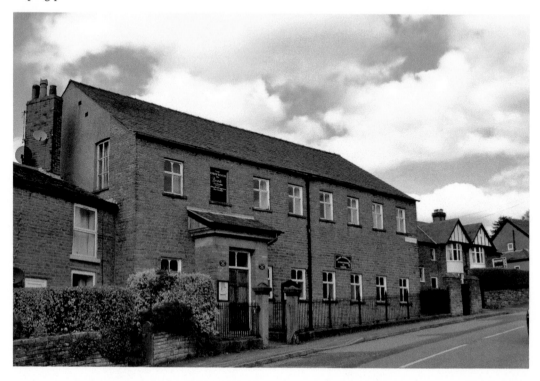

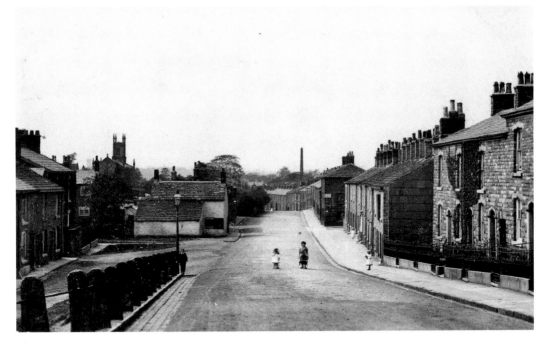

Hurdsfield Road, early 1900s
A bit further down now and we see the road as it used to be around the turn of the last century. The pub is The Britannia Inn which I don't have many details of, possibly due to a name change. The sandstone fence posts on the left are still there albeit a bit battered since the old photograph was taken.

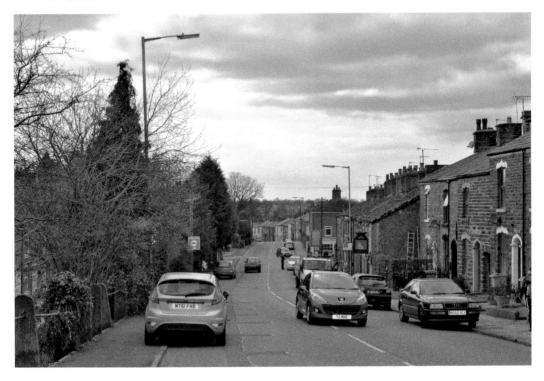

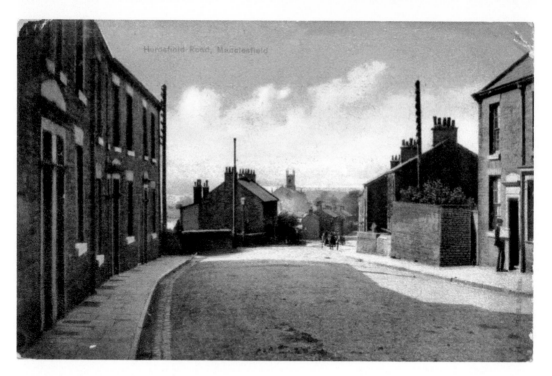

Hurdsfield Road, late 1800s early 1900s

A look now from further up the road, towards Macclesfield. At the end of the low wall are the steps down to the canal and in the distance you can see the tower of the Holy Trinity church. This Hurdsfield church was built in 1839 and in 1879, it became a parish in its own right.

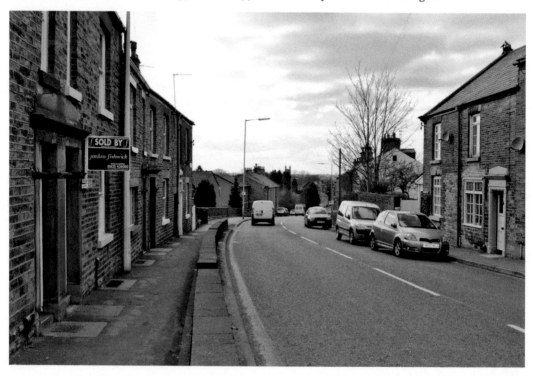

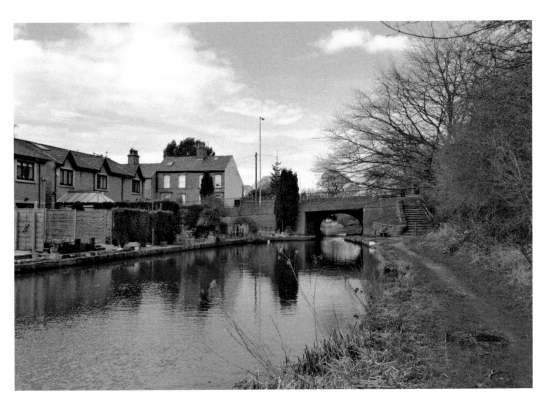

Canal Bridge Hurdsfield, early 1900s
This bridge, which has visibly been widened, carries Hurdsfield Road across the Macclesfield canal as it meanders its way towards Bollington. It is a popular canal with holidaymakers as it forms part of the Cheshire Ring.

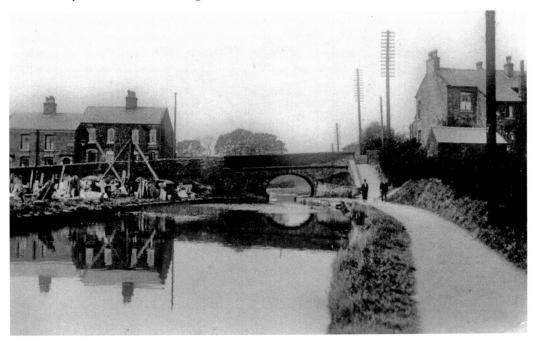

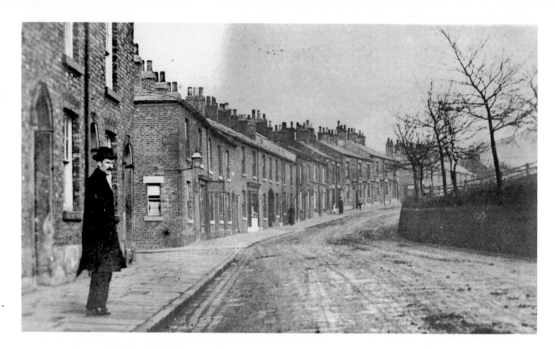

Lower Hurdsfield Road, early 1900s

We are now one mile from Macclesfield market place, looking up Hurdsfield Road. The man in the old photograph is standing outside what is now an excellent and long established Butchers & Pie Makers called Broadhurst whose pies I can highly recommend. I believe this building was originally a pub called the Red Lion up to the 1920s and that during the war it was the headquarters of the local Home Guard.

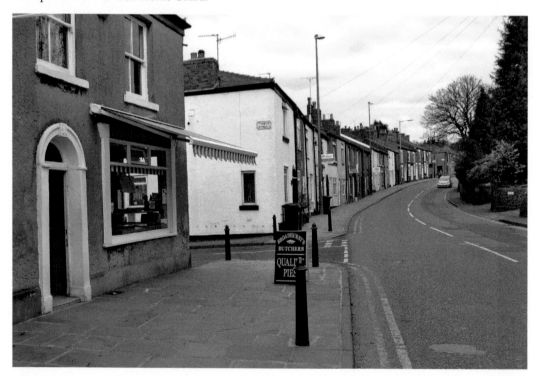

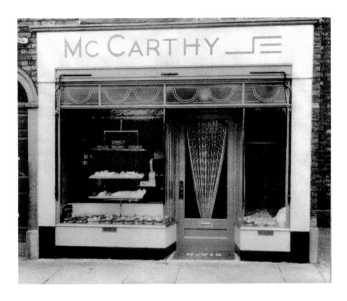

McCarthy Shop, Hurdsfield Road, 1920s–1940s

This old photograph was kindly lent to me by Mr Philip Broadhurst and it is of the shop next door to his, when it was a retail outlet.I estimate the date to be in the later 1930s as it is not shown in the 1934 directory. It was then a very attractive baker shop but has now been converted back to a dwelling house. McCarthy is a relatively common name in Hurdsfield today.

Military Barracks, Undated
Back in Macclesfield proper now is this militia barracks in Compton Street. It was built in 1858 to 1859 at a cost of £13,000 and was designed by Mr Pownall of London and local architect Mr James Stevens.
In 1896, they were occupied by the 4th Battalion the Cheshire Regiment (2nd Royal Cheshire Militia). A volunteer drill hall was built in Bridge Street in 1871 at a cost of £2,700. After a spell as a night club, some of the buildings were demolished with the remainder put to good class residential use.

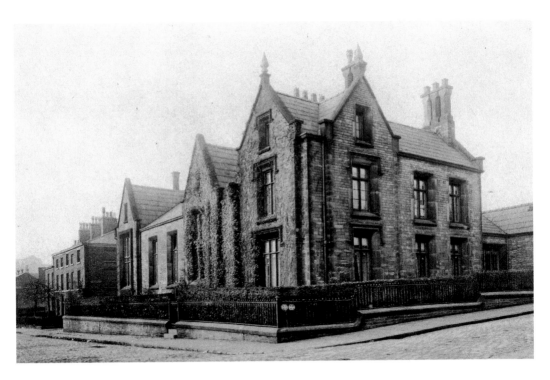

Modern School, Great King Street, Undated
These buildings were opened in 1844 as a modern school to run in tandem with the grammar school. Land from the Kings School was sold in order to purchase and build this school at the junction with Bridge Street. It is interesting to note the profuse growth of ivy on the wall in the old photograph.

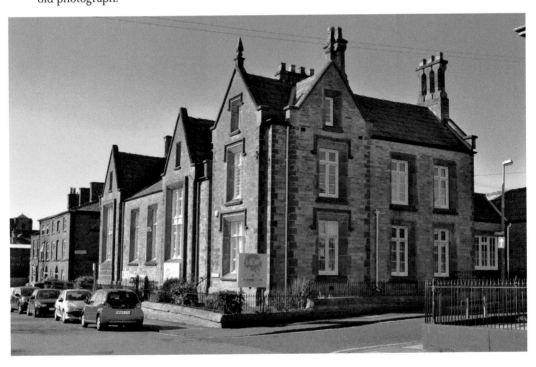

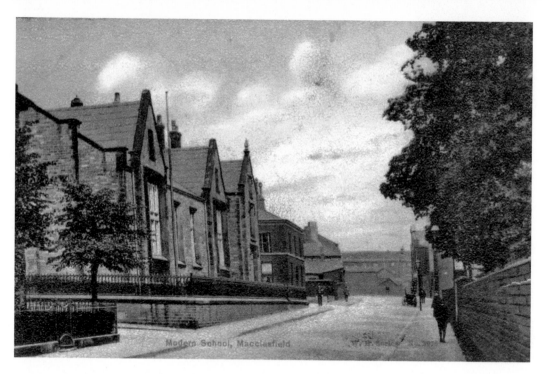

Modern School, Great King Street, early 1900s
In 1910 the grammar school in King Edward Street was combined with this modern school under the name of 'Kings School'. This building is now used by community agencies and the grammar school building is used as dwellings.

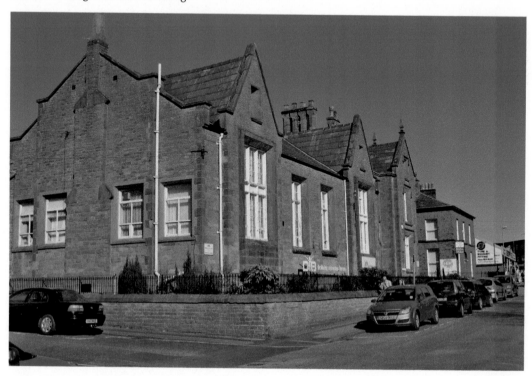

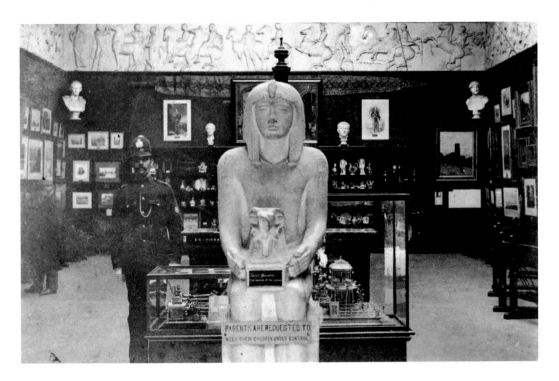

West Park Museum, 1920s–1930s
This very interesting museum is in West Park and the old photograph is of a display there. What the policeman is doing I don't know but the statue is still there in a different and dedicated display of Egyptian artefacts. I have included an inset here to show just how attractive this building is.

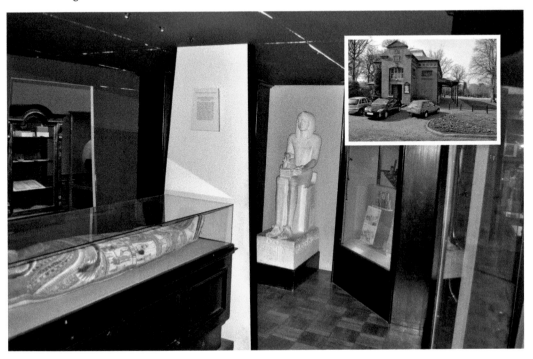

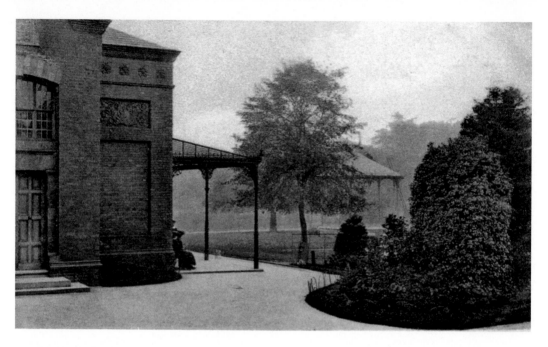

West Park, early 1900s

Outside the red brick building, the covered seating area is still there as it was over 100 years ago. The park has changed though, from a select area in which to take the air on a warm day, to a graffiti covered skateboard rink. Things have to change I suppose; but what has not changed is the museum and its excellent and helpful staff.

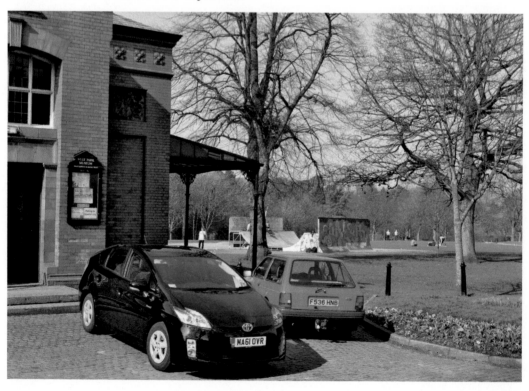

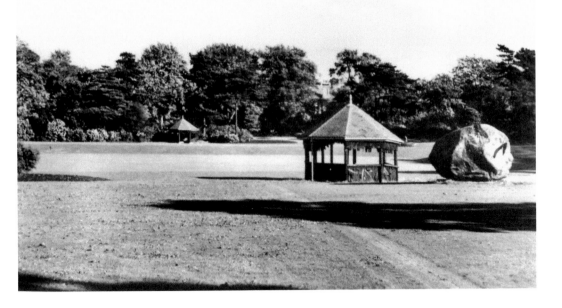

West Park with Rock, Undated

This rock or boulder mystifies many as to how it got here. Originally it will have been carried from Cumbria by the movement of a glacier during the Ice Age. This particular rock weighs about 30 tons and was presented to the park by Mr Joseph Beswick on the 24 July 1847, shortly after the park opened. It had been recovered from a field near Oxford Road.

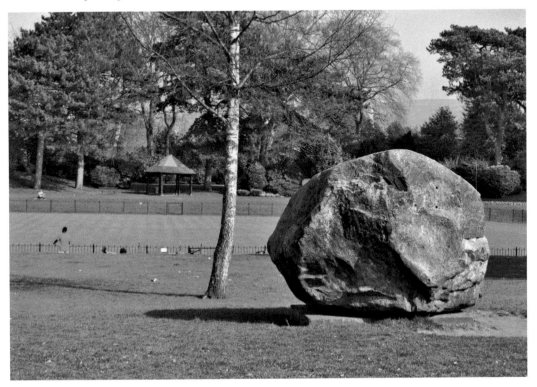

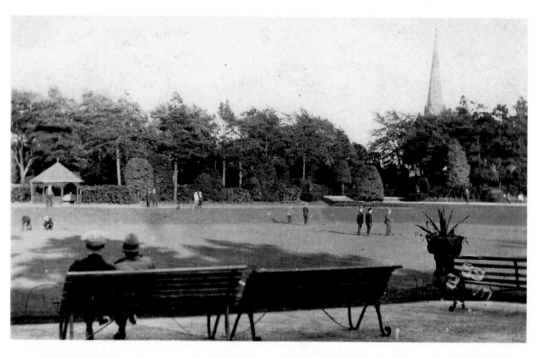

West Park, Undated
Here we have a final photograph of the park in its more leisurely days, with the sunken bowling green and the church spire in the distance.

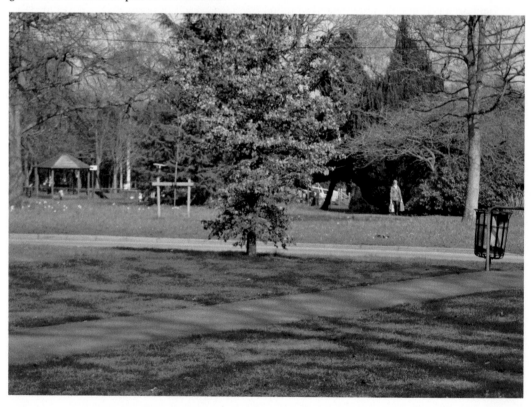

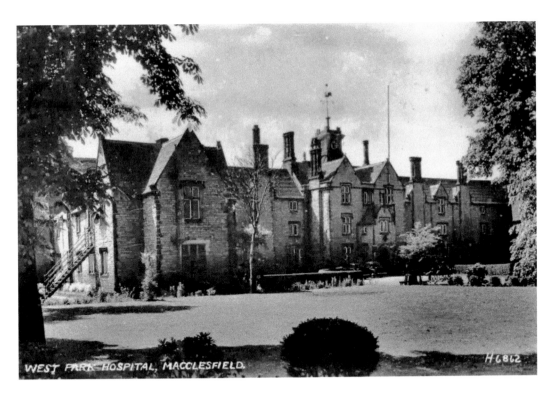

West Park Hospital, early 1900s

Built originally as an institution and workhouse in 1843–1845, from 1929 to 1947 it was the West Park Hospital and from 1949 to 1983 it was Macclesfield Hospital West Park Branch. After that, it became and remains Macclesfield District General Hospital, West Park Branch.

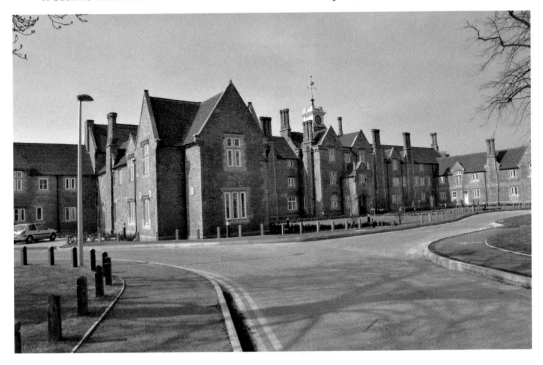

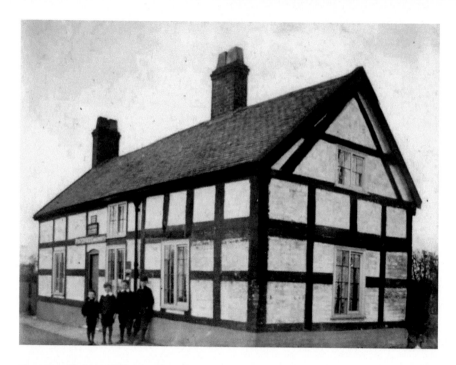

Gawsworth Post Office, early 1900s

Gawsworth is one of the most beautiful villages in Cheshire and this old post office building is situated on the Congleton Road crossroads. The last postmistress here was Audrey Baxter and she left in 1968. A temporary post office was set up in the village whilst the new one in Longbutts Lane was built.

So, there ends this look at Macclesfield, I hope you have enjoyed the comparison of old and new and that the captions may have sparked an interest in your local history.

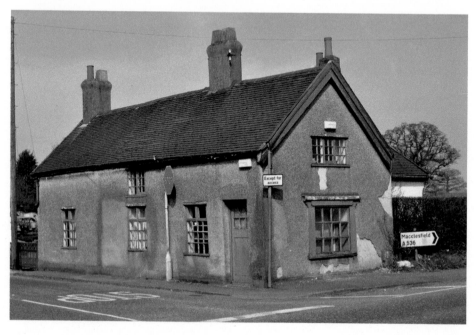